A CARNIVAL
OF LOSSES

A *New York Times* New and Noteworthy Book

"Donald Hall writes about love and loss and art and home in a manner so essential and direct it's as if he's put the full force of his life on the page. There are very few perfect books, and *A Carnival of Losses* is one of them." —Ann Patchett

"A freewheeling essay collection that's a fitting coda to a distinguished career . . . Hall may have reached his roundhouse but not before bequeathing readers with this moving valedictory gift." —*Washington Post*

"Hall lived long enough to leave behind two final books, memento mori titled *Essays After Eighty* (2014) and now *A Carnival of Losses: Notes Nearing Ninety*. They're up there with the best things he did." —Dwight Garner, *New York Times*

"[*A Carnival of Losses*] is a beauty, brimming with stories, confessions and faded snapshots in time in which he muses about life, settles a few scores and brags a little about his accomplishments. It's odd that a book whose subject is loss could be so uplifting. And yet it is. Hall may be telling us what it's like to fall apart, but he does it so calmly, and with such wit and exactitude, that you can't help but shake your head in wonder." —Ann Levin, Associated Press

"A joy to read." —*BookPage*

"It's a heartbreaking beauty of a book." —*Bookish*

"A joyful, wistful celebration of poetry, poets, and a poet's life . . . There's much to enjoy in these exuberant 'notes.'"
 —*Kirkus Reviews*

"Candid and often humorous . . . Hall's ruminative and detailed reflections on life make this a fantastic follow-up to his *Essays After Eighty*." —*Publishers Weekly*, starred review

"Hall offers a veritable sparkling necklace of pieces on aging, solitude, and the surprising joys of both, interspersed and embellished by memories." —*Library Journal*

"One of the best American poets . . . 'The Selected Poets of Donald Hall,' to which poetry lovers may turn first, [will] be delightfully surprised to discover they're more gossip than critique. There is much more about poetry, of course, most notably the longest entry, 'Necropoetics,' about elegies and other poems of death, ending with his, for his wife, the late Jane Kenyon. Another, longer piece may be the best: 'Walking to Portsmouth' tells the story behind Hall's Caldecott medalist children's book, *The Ox-Cart Man*. But they're all good." —*Booklist*

"*A Carnival of Losses* is frank about aging's sorrow. When Hall's dish is good, it's delicious." —*America* magazine

"A remembrance and a warning, a somber, sometimes funny, telling of life's hardship and disregard." —*Pasatiempo*

DONALD HALL

A CARNIVAL OF LOSSES: NOTES NEARING NINETY

MARINER BOOKS
HOUGHTON MIFFLIN HARCOURT
BOSTON NEW YORK

for the helpers

Kendel Currier

Carole Colburn

Pam Sanborn

Louise Robie

Mary Blake

First Mariner Books edition 2019
Copyright © 2018 by Donald Hall

hmhco.com

Library of Congress Cataloging-in-Publication Data
Names: Hall, Donald, 1928– author.
Title: A carnival of losses : notes nearing ninety / Donald Hall.
Description: Boston : Houghton Mifflin Harcourt, 2018. | Includes index.
Identifiers: LCCN 2017061816 (print) | LCCN 2017049735 (ebook) |
ISBN 9781328826312 (ebook) | ISBN 9781328826343 (hardback) |
ISBN 9780358056140 (paperback)
Subjects: LCSH: Hall, Donald, 1928– | Poets, American — 20th century. |
BISAC: BIOGRAPHY & AUTOBIOGRAPHY / Artists, Architects, Photographers. |
FAMILY & RELATIONSHIPS / General.
Classification: LCC PS3515.A3152 (print) | LCC PS3515.A3152 Z46 2018 (ebook) |
DDC 811/.54 [b] — dc23
LC record available at https://lccn.loc.gov/2017061816

Book design by Mark R. Robinson

Printed in the United States of America
DOC 10 9 8 7 6 5 4 3 2 1

P177 Garrison
P181 Fucking

CONTENTS

I

NOTES
NEARING
NINETY

YOU ARE OLD

YOU ARE OLD WHEN YOU LEARN IT'S MAY BY NOTICing that daffodils erupt outside your window. You are old when someone mentions an event two years in the future and looks embarrassed. You are old when the post office delivers your letters into a chair in your living room and picks up your letters going out. You are old when you write letters.

In your eighties it gets hard to walk. Nearing ninety it's exhausting to pull your nightshirt on.

You are old when the waiter doesn't mention that you are holding the menu upside down. You are old when an essay of reminiscence takes eighty-four drafts. You are old when mashed potatoes are difficult to chew, or when you guess it's Sunday because the mail doesn't come. It might be Christmas.

In your eighties you take two naps a day. Nearing ninety you don't count the number of naps. In your eighties you don't eat much. Nearing ninety, you remember to eat.

You are old when your longtime friend Melvin, turned seventy-five, writes you in rage about becoming old. Working to finish a new book, the author of *Essays After Eighty* tells Melvin that Melvin knows *nothing* about old age: Melvin can walk upstairs! Melvin flies to the West Indies with his girlfriend and his wife!

In your eighties you are invisible. Nearing ninety you hope nobody sees you. At nineteen you were six foot two. At ninety-one you will be two foot six.

SOLITUDE DOUBLE SOLITUDE

LATE IN MY EIGHTIES I REMAIN SOLITARY. I LIVE BY myself on one floor of the 1803 farmhouse where my family has lived since the Civil War. After my grandfather died, my grandmother Kate lived here alone. Her three daughters visited her. In 1975 Kate died at ninety-seven, and Jane and I took over the house. Forty-odd years later, two decades after Jane's death, I spend my days alone in one of two chairs. From an overstuffed blue chair in my living room, I look out the window at the unpainted old barn, golden and empty of its cows and of Riley the lame horse. I look at a tulip, I look at a 150-year-old maple, I look at snow. In the parlor's mechanical chair I write these paragraphs and dictate letters. Also I watch television news, often without listening, and lie back in the generous comfort of solitude. People want to come visit, but mostly I put them off, preserving my continuous silence. My friend Linda spends two nights a week with me. My two best male friends from New Hampshire, who live in Maine and Manhattan, seldom drop by. A few hours a week Carole does my laundry and counts out my pills and picks up after me. I look forward to her presence and feel relief when she leaves. Now and then, especially at night, solitude loses its soft power and loneliness takes over. I am grateful when solitude returns.

Born in 1928, I was an only child. In the Great Depression there were many of us, and Spring Glen Grammar School was eight grades of children with few siblings. From time to time I made a friend during childhood, but friendships never lasted

long. Charlie Axel liked making model airplanes out of balsa wood and tissue. So did I, but I was clumsy and dripped cement onto wing paper. His models flew. Later I collected stamps, and so did Frank Benedict. I got bored with stamps. In seventh and eighth grade there were girls. I remember lying with Barbara Pope on her bed, fully clothed and apart while her mother looked in at us with anxiety. Most of the time I liked sitting alone after school in the shadowy living room. While my mother was out shopping or playing bridge with friends and my father added figures in his office, I daydreamed.

In summer, I left my Connecticut suburb to hay with my grandfather on this New Hampshire farm. I watched him milk seven Holsteins morning and night. For lunch I made myself an onion sandwich, a thick slice between pieces of Wonder Bread. At fifteen I went to Exeter for the last two years of high school. Exeter was academically difficult and made Harvard easy, but I loathed it — seven hundred identical Republican boys, living two to a room. Solitude was scarce, and I labored to find it or to make it. I took long walks alone, smoking cigars. I found myself a rare single room and remained there as much as I could, reading and writing. Saturday night the other students gathered in the basketball arena, deliriously watching a movie. I remained in my room in solitary pleasure.

At college, dormitory suites had single and double bedrooms. For three years I lived in one bedroom crammed with everything I required. In my senior year I managed to secure a single suite: bedroom and sitting room and bath. At my Oxford college I had two rooms to myself. Everybody did. Then I had fellowships. Then I wrote books. Finally, to my distaste,

I had to look for a job. With my first wife — people married young back then; we were twenty and twenty-three — I settled in Ann Arbor and taught English literature at the University of Michigan. I loved walking up and down in the lecture hall, talking about Yeats and Joyce or saying aloud the poems of Thomas Hardy, John Keats, and Andrew Marvell. These pleasures were hardly solitary, but at home I spent the day in a tiny attic room working on poems. My extremely intelligent wife was more mathematical than literary. We lived together and we grew apart. For the only time in my life I cherished social gatherings, Ann Arbor's culture of cocktail parties. Back then, I found myself looking forward to weekends, to crowded parties that permitted me distance from my marriage. On two or three such occasions, on Friday and more on Saturday, we flirted, we drank, we chatted — without remembering on Sunday what we talked about on Saturday night.

After sixteen years of marriage, my wife and I divorced.

For five years I was alone again, but without the comfort of solitude. I exchanged the miseries of a bad marriage for the miseries of bourbon. I dated a girl who bragged that she drank two bottles of vodka a day. I dated three or four women a week, rarely two in a day. My poems slackened and stopped. I tried to think that I lived in a happy licentiousness. I didn't.

Jane Kenyon was my student. She was smart, she wrote poems, she was funny and frank in class. After the term ended, because I knew she lived in a dormitory near me, one night I asked her to house-sit while I attended an hour-long meeting. (In Ann Arbor, 1970 was the year of breaking and entering.) When I came home, we went to bed. We enjoyed each other,

libertine liberty as much as pleasures of the flesh. Later I asked her to dinner, which in that decade always included breakfast. Often we saw each other once a week, still dating others, then twice a week — then three or four times a week, seeing no one else. One night we spoke of marriage. Quickly we changed the subject, because I was nineteen years older, and if we married she would be a widow so long. We married in April 1972. We lived in Ann Arbor three years, then left Michigan for New Hampshire. She adored this old family house.

For almost twenty years I woke before Jane and brought her coffee in bed. When she rose, she walked Gus the dog. Then each of us retreated to a workroom to write, at opposite ends of our two-story house. Mine was on the ground floor in front, next to Route 4. Hers was on the second floor in the rear, by Ragged Mountain's old pasture. In the separation of our double solitude we each wrote poetry in the morning. We met for lunch, eating sandwiches and walking around without chatting. Then we took a twenty-minute nap, gathering energy for the rest of the day, and woke to our daily fuck. Afterward I felt like cuddling, but Jane's climax released her into energy. She hurried from bed to workroom.

For several hours afterward I went back to work at my desk. Late in the afternoon I read aloud to Jane for an hour. I read Wordsworth's *Prelude*, Henry James's *The Ambassadors* twice, the Old Testament, William Faulkner, seventeenth-century poets, Raymond Carver's stories, more Henry James. Before supper I drank a beer and glanced at *The New Yorker* while Jane cooked, sipping a glass of wine. Slowly she made a good dinner — maybe veal cutlets with mushroom and garlic gravy,

maybe summer's asparagus from Jane's plot across the street — then asked me to carry our plates to the table while she lit the candle. Through dinner we spoke of our separate days.

Summer afternoons we spent beside Eagle Pond on a bite-sized beach among frogs, mink, and beaver. Jane lay in the sun tanning while I read magazines in a canvas sling chair. Every now and then we would plunge into the pond. Sometimes for an early supper we broiled sausage on a hibachi. After twenty-three years of an extraordinary marriage, twenty New Hampshire years living and writing together in our double solitude, Jane died of leukemia at forty-seven in 1995.

Jane has been dead for more than two decades. Earlier this year I grieved for her in a way I had never grieved before. At eighty-six, I was sick and thought I was dying. Twenty and twenty-one years ago, every day of her dying for eighteen months, I stayed by her side. It was miserable that Jane should die so young, and it was redemptive that I could be with her every hour of every day. Last February I grieved again, this time that she would not sit over me as I died.

DICTATERS

PEOPLE WHO DICTATE LETTERS MUST PROOFREAD, because one word sounds like another. Especially they must proofread addresses. I live on Eagle Pond Farm, named by my great-grandfather for its twenty acres of water nearby. The Red Sox broadcaster Ned Martin wrote me a letter at Evil Pond Farm. I tack the envelope on a parlor wall alongside an envelope from the late Stephen Jay Gould. He and I also exchanged a letter or two. Gould was a biology professor at Harvard, eloquent and vastly intelligent, who wrote short scientific essays crafted in witty prose. It's true that when we read him we detect his appropriate and exalted opinion of Stephen Jay Gould. He addressed me at Ego Pond Farm.

IN PRAISE OF PARAGRAPHS

WHEN I STOPPED WRITING POEMS, IN 2010 OR SO, IT was a relief. Quality had diminished along with testosterone. How many good poems are written by people in their eighties? I hoped that prose might continue. One day in the mail came a letter from a small press that designed and set exquisite books printed in editions of fifty at a notable price. This press had beautifully executed small collections of my poems as well as the handsomest broadside I ever saw. They knew that in old age I sat all day in a chair looking out my window at the cow barn's unpainted vertical boards. They asked if I would write an essay called "Out the Window," which they would make into a small and elegant book. I said I was sorry but I couldn't do it.

The next day I started "Out the Window." It took me fifty drafts over six months, and when I finished, I wanted the essay to find readers, not collectors. I sent the manuscript to the fine press, thanked them for the topic, and asked if I could please show it to a magazine. It came out in *The New Yorker* and started me on *Essays After Eighty*.

Most of my life, I've been at my best early in the day. These days I start writing prose first thing in the morning, as I used to do with poems. After "Out the Window," I worked on further essays with passion and concentration. Some pieces took as many as eighty drafts. Rewriting, I turned an adjective-noun into a particular, more appropriate noun. I removed an adverb and tried twenty verbs before I found an exact and

witty one. New topics kept arriving. "Three Beards" could recall student protests during the Vietnam War, grief over Jane's death, laughter, recipes, tears, and a widower's lust.

My prose continued in a direction that my poems had taken over the years. When I was young, my language wore coats and shirts and trousers, neckties, bespoke shoes. In my lifetime as a writer I have cast off layer after layer of clothing in pursuit of nudity. I hold nothing back except transitions that might once have elaborated notes into an essay. In a paragraph or two, my prose embodies a momentary victory over fatigue. As I write toward my nineties I shed my skin. I tell short anecdotes, I hazard an opinion, speculate, assume, and remember. Why should the nonagenarian hold anything back?

MY NEW HAMPSHIRE GRANDMOTHER

KATE NEVER HAD ANY MONEY, BUT SHE LOVED TO save it. When she was ninety-three her youngest daughter took her to a dollar store where she found an elevated tray filled with tiny aluminum percolators, one-cuppers. The frank and ethical enterprise attached a notice informing its customers that these percolators did not work. They were only 5 cents, so Kate bought two of them anyway.

SEVEN HUNDRED WORDS

WHEN I WAS SIXTEEN I READ TEN BOOKS A WEEK:
E. E. Cummings, William Faulkner, Henry James, Hart Crane,
John Steinbeck. I thought I progressed in literature by reading
faster and faster—but reading more is reading less. I learned
to slow down. Thirty years later in New Hampshire with Jane,
I made a living by freelance writing all day, so I read books
only at night. Jane went to sleep quickly and didn't mind the
light on my side of the bed. I read *The Decline and Fall of the
Roman Empire* and six huge volumes of Henry Adams's let-
ters. I read the late novels of Henry James over and over again.
After Jane died I kept reading books, at first only murderous or
violent writers like Cormac McCarthy. Today I am forty years
older than Jane ever got to be, and I realize that I haven't fin-
ished reading a book in a year.

An athlete goes professional at twenty. At thirty he is slower
but more canny. At forty he leaves behind the identity that he
was born to and that sustained him. He diminishes into fifty,
sixty, seventy. Anyone ambitious, who lives to be old or even
old, endures the inevitable loss of ambition's fulfillment. In
a Hollywood retirement home to meet a friend, I watched a
handsome old woman in a wheelchair, unrecognizable, leap up
in ecstasy when I walked toward her: "An interview!" she said.
"*An interview!*" A writer usually works until late in life. When
I was eighty, still doing frequent poetry readings, audiences
stood and clapped when I concluded, and kept on clapping un-
til I shushed them. Of course I stayed to sign book after book,

and returned to my hotel understanding that they applauded so much because they would never see me again.

Suppose I am the 150-year-old maple outside my porch. When winter budges toward spring, I push out tiny leaves, which gradually curl yellowish green then enlarge, turning darker green and flourishing through summer. In September flecks of orange seep into green, and October turns the leaves gorgeously orange and red. Leaves fall, emptying the branches, and in December only a few remain. In January the last survivors flutter down onto snow. These black leaves are the words I write.

Back then, I wrote all day, getting up at five. By this time I rise scratchy at six or twitch in bed until seven. I drink coffee before I pick up a pen. I look through the newspaper. I try to write all morning, but exhaustion shuts me down by ten o'clock. I dictate a letter. I nap. I rise to a lunch of crackers and peanut butter, followed by further exhaustion. At night I watch baseball on television, and between innings run through the *New York Times Book Review*. I roll over all night. Breakfast. Coffee.

When Jane was alive, our dog Gus needed walking every day. Jane walked him when she waked, feeling sleepy before breakfast. When they left I lifted my hand from the page, waving goodbye. Midday we had lunch and a nap and then I walked Gus. In my car I drove him up New Canada, the dirt road near our house, and parked where the single lane widened. We walked the flat earth, not for long because I wanted to get back to manuscript again. Now when someone brings a

dog to the house, I barricade myself in a big chair. An attentive dog would break my hip.

Louise is my cat. Ten years ago, her vigorous sister Thelma squirmed out of the house and discovered Route 4. My assistant Kendel dug a hole and we set a half-barrel over the grave to impede hungry animals from enjoying a Thelma snack. Louise is passive, too shy to scoot through an open door. At night when I watch MSNBC, she annoys me by rubbing my knee, but she never knocks me over.

Striving to pay the mortgage in the late 1970s and '80s, some years I published four books. Now it takes me a month to finish seven hundred words. Here they are.

LOSING MY TEETH

WHEN I TREKKED INTO MY EIGHTIES, MY LAST TEETH wiggled loose in my bottom jaw and I was toothless. For decades an upper plate had sufficed, but now I also needed a full lower plate, if I were to gnaw meatballs into my gullet. Dental machinery is difficult for me, because my jawbones and gums are so thin that hardware can't find a purchase. Because of the vacuum my uppers stay stuck with only a touch of glue, but not the lower plate. My tongue flails up through the dental horseshoe and the polymer teeth fly out even though I have applied a pint of adhesive. Sometimes they slip loose while I'm chewing in a restaurant. I hold a napkin to my face and tuck the loathsome slimy pink object into a jacket pocket.

Between meals at home, I used to keep my lowers on a shelf beside my blue chair, and every day I lost them. I lost them because I couldn't abide them. Since I can't go outdoors, they had to be nearby. I don't have a dog that eats dentures, and my cat's mouth is too small. Each time I lost my teeth, I stared at every tabletop and shelf top. I looked at places where they couldn't possibly be, and once or twice that's where they were. My trainer Pam comes Tuesdays and Thursdays to stride me on a treadmill and punish me with weights. Once as I was pacing through cardio, my teeth shot out. I tucked them into a small tray beside the treadmill's panel of knobs and buttons. Did I hide them on purpose? I gummed my food for two days until Pam came back. Only a woman can find what I lose. A few years ago I spent three months in New York. I had my own

teeth then, and never misplaced them, but I wore bifocals, and when I couldn't find them I telephoned Kendel in New Hampshire and she told me where they were. (I don't lose my bifocals now because I no longer wear them. I won't tell you why.) Once I was in my bedroom when the telephone rang on the far side of my bed. I was talking to my friend Jeff when my teeth flew out. Talking often flies them out. Linda sleeps on that side of the bed and found them that night.

Another time I couldn't find them anywhere, and Linda was soon to arrive. My fecklessness shamed me. I remembered putting them on top of my rollator, under a throwaway piece of cardboard next to a mug of cold coffee. I tossed the cardboard, set the mug beside the coffeemaker, and when I got back to my blue chair, my teeth were missing. I checked the wastebasket where I threw the cardboard. I checked the coffeemaker. When Linda walked in, I told her I had lost my teeth, and she reached down beside her chair and picked them up. Later that day, they zapped out of my mouth onto the floor of the bathroom between the washing machine and the dryer. Linda poked them out with a broom handle.

It was a week before I lost them again. I heated up supper one night, take-home flatbread with shaved steak and stewed tomatoes and hot peppers. I warmed it in the toaster oven and brought it to the parlor, where every night I watch the Red Sox. Often I eat supper in my mechanical chair, so I keep a tube of glue beside it. This time I found the glue but not the teeth. They weren't among the strategic piles of papers, tucked away so that I would never forget them, where I always forget them. The flatbread went cold and I stuffed it into the take-

home box and back into the refrigerator. I gummed a banana, not difficult, and tried gumming cheddar, not easy. When Kendel brought me my breakfast sandwich I wrapped myself in a bath towel and chomped my oozy meal, slithering sausage, fried egg, and English muffin into my mouth and onto my beard, my bath towel, and my lap. When Linda dropped by at noon, she wouldn't look at me, but she picked my teeth out of the wastebasket.

She also had a great idea. After every meal, after my lower plate flopped out after every meal, I should lift up my rollator seat—my rollator confronts me at all times—and plop my pink horseshoe plate (horseshoe crab, crabby horseshoe) into the bin under the seat. Her great idea is virtually foolproof, but some fools can outdo any proof. In one month after Linda's suggestion, I lost my teeth twice. Staring at the empty bin of the rollator, I wailed out loud, "Where are my teeth?" The wailing did it. My teeth were in my mouth.

DEPRAVITY

WHAT IS THE WORST THING I EVER DID? THERE MUST be many worst things. I recollect shameful moments in my first marriage, and in behavior with my small son. A momentary scene fixes itself in my head. Andrew was three years old, noisy and affectionate, needy, darling, and annoying. Mother, father, and son lived in a ranch house outside Boston. I wrote my poems in the cellar, where I kept a desk, a wormy sofa, two chairs, and books on shelves held up by bricks. To the door at the top of the stairs I hammered a hook and eye so that I could close myself off. One morning I left the house briefly. When I returned I was eager to get back to a poem at my desk, but Andrew stood in my way. I pushed past him and set a foot on the top stair, trying to fasten the hook behind me. Andrew called, "Daddy! Daddy!" and held on to my leg. "You're a bad boy," I told him in rage. "You're a bad boy!" His face crumpled and reddened. Being called a bad boy was the most devastating accusation possible. With passionate humiliation at the age of three, his red curls shaking, he insisted, "I'm *not* a bad boy, Daddy! I'm *not* a bad boy!"

I hooked the door shut, climbed down to my desk, and picked up my pen.

PARIS 1951

FROM OXFORD, IN 1951, I FLEW OVER TO PARIS BE-
tween terms, and dated a French girl once or twice. Her mother
was English, which helped her when we chatted, but some-
times she got the tone wrong. When I asked her what she'd like
to do next—Drink a *sérieuse blonde* at Brasserie Lipp? Take a
look at the Luxembourg Gardens? Listen to Sidney Bechet at
Vieux-Colombier?—she always told me benignly, "I couldn't
care less."

CUTTING A FIGURE

MY MOTHER IN HER MID-EIGHTIES WORE THE SAME thing every day, a long and voluminous device that she called a caftan. It reached from her shoulders to the floor, was easy to put on and take off, and required no underwear. When she walked hunchbacked to warm her oyster stew or to squat in the WC, her caftan was sufficient.

From birth to death, we inhabit one sort of clothing after another. At first I dressed transgender. I keep a photograph in my bedroom in which I am one year old, sitting on a baby's rocking chair with long blond ringlets and wearing a fancy dress, smiling as if the camera were a nipple. (It remained the best picture of me until the cover of *Essays After Eighty*.) In kindergarten five-year-old girls wore skirts, and when they did cartwheels you noticed the underpants. Little boys always wore knickers. How long ago did boys stop wearing knickers? Knickers were corduroy pants that went from the waist to just below the knee, where elastic clamped them on top of long socks. Football players today wear knickers, but with their helmets and shoulder pads they don't look like 1936 fifth-graders. Some baseball players tuck in their uniform pants at the knee, above their stockings, and resemble the boys of Spring Glen Grammar School.

Finally came the year of long pants, a step up the ladder of manhood, like playing with yourself or shaving. Was there a comparable moment for girls? From knee socks to garter

belts? I wore long pants into my eighties. For my poet lau-
reateship appearances in Washington, DC, I bought a tailor-
made brown tweed suit. It fit my two hundred pounds. Then
an incompetent medical facility prescribed me, off-label, an
atypical antipsychotic called Zyprexa, "to encourage sleep."
It encouraged depression, it encouraged Parkinsonian symp-
toms, it encouraged no appetite. Without knowing I was do-
ing it, I smacked my lips together every thirty-seven seconds.
I lost sixty pounds, and my pants didn't fit anymore. I tried
wearing suspenders, and my trousers dangled eight inches
beyond my belly. Finally rid of Zyprexa, I gained weight
back and could wear the suit, but had nowhere to wear it.
Later, for a ceremonial occasion, I wanted to wear my tai-
lor-made tweed again, but moths had consumed the trousers.
When President Obama bemedaled me, I wore khakis. Later,
a series of belts never cinched my waist, and my pants fell
down. For Christmas I asked my son for pants with suspender
buttons on the inside, but my shoulders sagged toward my
knees and my pants fell down.

When I had trouble tying my tie and it took half an hour
to button a shirt, I graduated to T-shirts all year, long sleeves
in winter, in summer short. But for my legs? Linda thought
maybe sweatpants might work, and bought me two mediums.
They were too big and my pants fell down. Then Linda found
small sweatpants, five dollars each at Walmart by way of Ban-
gladesh. I am equipped for the remainder of my life, except
for the penultimate johnny and the ultimate shroud. I dress
almost as easily as my mother did in her caftans. The sweat-

pants hold up all day and don't fall down. Gradually the elastic cuffs crawl from my ankles up to my knees, returning me to the knickers of Spring Glen Grammar School, or much better, to the Boston Red Sox.

"THE WILD HEIFERS"

MY FIRST PROSE BOOK STARTED, MORE OR LESS, IN 1944 at Exeter, when I wrote a free theme for my English teacher about chasing wild heifers with my grandfather. With Exeter's remarkable grade deflation, I was pleased to get an unprecedented A. My summers on the New Hampshire farm were the passion of my life from fifth grade on. When I went off to college, those days remained at memory's center. After graduation, alone in London in late summer of 1951, on my way to Oxford, I wandered in the city of pubs and sausages remembering my grandfather and my summers of haying.

Oxford took over. In my second year I married and my New Hampshire grandfather died. The following year I took a fellowship in California and my son Andrew was born. Then for three years I reveled in a grant that allowed me to do anything at all, so of course I worked on poems every day. After six years on the academic dole, at last I had to get a job. What ignominy. I became an assistant professor of English at the University of Michigan. My chairman understood that I wanted to teach afternoons only, saving the mornings for writing, but in the second term of my second year he gave me a 10 a.m. class. When I reminded him of my preference, he smiled sweetly and remarked, "We can't always have what we want, can we?" I accepted his appropriate rebuke.

Shortly thereafter another university, many miles east, invited me to read my poems aloud, then asked me to join their

staff. They offered me tenure, a full professorship at double my Michigan salary, with classes only Tuesday and Thursday afternoons. I could take leave without pay whenever I wanted. I flew back to Michigan with regret. I understood that I had to move out of Ann Arbor where I was just making friends. Also the Detroit Tigers were only an hour away, and the Detroit Lions, and the Detroit Pistons. I told my chairman about the offer I could not refuse. He told me that of course I could have whatever I wanted.

My wife and I would remain at the University of Michigan, but first I would take leave without pay and spend some time in England so that I could write all day. I had saved up two thousand dollars to take a year off for writing. In England, I reviewed books, performed small literary tasks, and talked on BBC radio — enough so that we sailed back home with two thousand dollars. It was my first year of freelancing. Every morning I got up early and worked on poems, and after Andrew left for the village school I attended to my correspondence and did chores. After lunch and a nap, I retreated to the music room on the second floor of the house and tried to write prose. I began with a story about pursuing wild heifers with my grandfather.

Earlier my prose had been only book reviews and academic papers or lectures, so at first my paragraphs about chasing virgin cattle sounded like an English professor promoting the New Criticism. I required a different voice to describe pursuing untethered young cows. When I showed my wife a draft of the first chapter, she prodded my language from lit crit to-

ward hay chaff and Holsteins. After eighteen drafts, at last I finished "The Wild Heifers" and continued in afternoons to accumulate other stories for the book I published two years later as *String Too Short to Be Saved.* I wondered if a magazine might publish a chapter. I sent "The Wild Heifers" to *The New Yorker*—they had printed my poems—and received a polite refusal. I decided this book wouldn't do for magazines. After almost a year we sailed home.

Back in Ann Arbor, I sent the manuscript of *String Too Short to Be Saved* to the Viking Press, which had published books of my poems. They liked it and scheduled it for publication. Pat MacManus (I don't forget her name) handled promotion for Viking, and sent bound galleys to magazines for review, or to anyone who might take notice. Most of her prepub copies had left the office when she thought of sending one to E. B. White. The famous essayist had lived in Manhattan and written for *The New Yorker* (with a sideline of children's books) but had returned with his editor wife Katharine to Maine, where he was devoted to the countryside, and continued to write measured and majestic prose. My telephone rang and it was Roger Angell, E. B. White's stepson by Katharine's first marriage, who had become a *New Yorker* editor. He spoke with excitement about the book his stepfather had mailed him. Everyone loved my stories, he told me, and *The New Yorker* wanted to publish "The Wild Heifers" and another chapter, about picking blueberries on Ragged Mountain. He added that if they had known of these stories earlier, they would have published more of them. In delight and

revenge, I told him that *The New Yorker* had rejected "The Wild Heifers." He looked at the editorial notes and found that two editors had *liked* it before they rejected it. He apologized with chagrin and asked me never, ever, to tell anyone this story.

SYCOPHANTS AND SISTERS

BACK IN THE OLD DAYS, YOU COULD DONATE YOUR letters or papers to a rare book library, usually at some university, and deduct the value of your gift from your income tax. As a senior in college, I edited an anthology of celebrated juvenilia from Harvard's undergraduate literary magazine, gathering letters of permission from the estates of two dead presidents named Roosevelt and from living writers like Norman Mailer and Wallace Stevens. In his letter Stevens wrote, "Some of one's early things give one the creeps." In the sixties, I donated these letters to the Houghton Library at Harvard and took my deduction. A few years later, when Richard Nixon resigned the presidency, he donated his papers to the National Archives and paid no income tax for the rest of his life. An indignant Congress passed a law that ended tax deductions for one's papers. Soon I read about universities buying archives from novelists and poets. The Harry Ransom Center, at the University of Texas, seemed especially avid.

Some institutions, naturally enough, still labored to acquire manuscripts and papers as gifts from writers, exploitation by the engines of sycophancy. Maybe attention is what a writer wants? Whenever the telephone rings, it's the king of Sweden: "The Nobel Prize Committee has asked me to inform you . . ." Vain flattery is as close to the king of Sweden as most of us are likely to get. Vanity presses profit by printing the books of unpublishable writers. Vanity anthologies

advertise POETS WANTED, accept everything submitted, and charge contributors a C-note for the repellent sequent assemblage.

In my English Department mailbox some years ago I found a letter from a librarian:

Dear Mr. Hall,

I am sure that many institutions have been in contact with you asking that they might become the repository of your manuscripts and correspondence files. I write to say that Boston University would be honored to establish a David Hall Collection, and to plead our particular cause for these reasons.

We are in the midst of planning the building of a magnificent new library on our Charles River Campus and we hope to make this library a center of study and research in contemporary literature. Up to the present time Boston University has been growing so rapidly as a "national" institution, that we have waited until we were ready with the proper facilities before establishing such a literary research center. With the advent of our new building we are now ready to embark upon this project.

It is our hope to collect the papers of outstanding contemporary literary figures, house and curate these materials under the optimal archival conditions, and attract to us scholars in the field of contemporary literature who would utilize our institution as a research base.

A David Hall Collection would certainly be a distinguished nucleus around which this University could build a great literary center. Your papers would be preserved for future generations. I do hope that you will look sympathetically upon our

request. May I say personally how much I have enjoyed your published work.

> Sincerely yours,
> Howard B. Gotlieb
> Chief of Reference and
> Special Collections
> Boston University Libraries

In the extremity of his personal enjoyment, the Chief of Reference and Special Collections mistook the name of his nucleus. Of course I thanked him on David Hall's behalf. Mr. Gotlieb answered, apologizing, saying that he "dictated my letters and when my secretary puts them on my desk for signature, I sign without reading."

His letter didn't *sound* dictated. Could he have said "Donald" out loud three times, in address and in tribute, and his secretary have mistaken "Donald" for "David" three times? It's true that his praise was dazzlingly general. The letter could have been addressed to a novelist or a cookbook writer or a gossip columnist or a poet. Maybe Gotlieb told his secretary to send the letter to W. S. Merwin, Ellery Queen, Danielle Steel, David Hall, and Irma S. Rombauer. If Gotlieb solicited the papers of 400 writers, and thirty years later his praise had entrapped one Nobel Prize winner, his institution could cheerfully discard 399.

Then an English novelist friend of mine forwarded me the same letter, word for word, except that it proposed "the John Bowen Collection" as its nucleus for a great literary center. My Oxford friend had asked BU if they might give him a pound or two, and Mr. Gotlieb hadn't answered. I had already mailed

several friends a copy of the David Hall letter. A poet from California replied, sending me a column from the *Saint Magazine* in which Leslie Charteris, author of the *Saint* thrillers, bragged to his fans that he had received undoubtedly the most flattering letter of his whole life. He printed a letter proposing "the Leslie Charteris Collection."

With enthusiasm I wrote a brief essay for the *American Poetry Review* called "The David Hall Collection." As a result, I received a letter from John Silber, the president of Mr. Gotlieb's Boston University. The *Boston Globe* often referred to "Silber Shockers," the president's misogynistic or homophobic letters attacking folks who slighted the institution he promoted. With his notorious good taste, Silber asked me what I would prefer — that my sister sell it or give it away.

IN 1975, Jane Kenyon and I moved to my family farm to freelance and I resigned my Michigan professorship. To make a living, I wrote magazine editors to solicit assignments, and a year or so later the *Atlantic, Harper's Magazine,* and *Sports Illustrated* were soliciting me back. But first, to pay the mortgage, I sold half a ton of manuscripts, letters, and publications to the University of New Hampshire. UNH continued to buy my annual crop into my eighties. I'm told they have accumulated and preserved a monstrous archive of letters, among which Silber's and Gotlieb's impeccably reside.

GEOGRAPHY

IN CAMBRIDGE, MASSACHUSETTS, I WAS LOOKING FOR employment. When it seemed possible that the University of Michigan might offer a job, I looked on a map to see which side of the Mississippi it was on. It was the usual boring easterner stuff. American geography is bizarre. Once in California I chatted with an eighty-year-old Los Angeles cousin who spoke of Texas as the Middle East. When I moved to Michigan, Ann Arbor astonished me. People could talk; they could even read and write. The city had an art museum and an auditorium for musicians on tour. Executives from the automobile business in Detroit took residence in Ann Arbor for music and theater and notorious cocktail parties. One such was our neighbor Robert McNamara, who ran Ford Motor Company before he ran the Vietnam War.

Naturally there were differences between one place and another. When I was in Boston, I told an anecdote about something that happened when I was "at Harvard." In Ann Arbor —as in Des Moines, as in Santa Monica, as in Atlanta—it happened when I was "in college."

THE BEARD GENERATION

JUST LATELY, I HAVE WATCHED BEARDS RETURN TO the United States.

George Washington, Thomas Jefferson, Alexander Hamilton, the Adams boys, and James Madison were shaved mostly by slaves with straight razors. Then Abraham Lincoln grew a beard. Poets with three names wore beards, except for Edna St. Vincent Millay. Ezra Loomis Pound wore a beard. T. S. Eliot wore initials. I grew my first beard halfway through the twentieth century, when they were shocking. The English Department where I taught had a hundred teachers with hairless faces, only three of whom were female.

Sixty years later, baseball players grow beards. Imagine Lou Gehrig with a beard! Jackie Robinson! Babe Ruth! Ted Williams! The Red Sox won the 2013 World Series wearing beards. There are beards under football helmets and above LeBron James's basketball uniform. Some hockey players wear beards, although they are Canadian. In Waco, Texas, police arrested 170 bikers for shooting at gangs of other bikers. Nine dead. Bail was set at a million dollars each biker. When newspapers published 170 mug shots, you could count 168 beards.

Soon everybody will shave.

THE VAPER

IN *ESSAYS AFTER EIGHTY* I WROTE A PIECE CALLED "No Smoking," about my forty-odd years of Chesterfields, Kents, and Pall Malls. The first paragraph listed fifty-two places where in 1955 everybody used to smoke, including at the movies and in a thoracic surgeon's office. It ended with a list of places where now *nobody* smoked, including a thoracic surgeon's office and at the movies. No one knows what happened next in my life until he or she reads these words. I never thought I would stop smoking, because I had tried nicotine patches, lozenges, self-abuse, mood-altering pills, starving to death, eating too much, and chewing nicotine gum. While *Essays After Eighty* was slogging into print I read in the paper about electronic cigarettes. I've always avoided everything electronic, but I bought an electronic cigarette in order to brag that I tried it out. I boosted up the battery, assembled it, and took a drag. I took another drag, then another. I *liked* it. I preferred vaping to smoking because it hurt my chest more than cigarettes did. When your lungs hurt, you know they're there. In order to make sure I wouldn't regret giving up tobacco, I kept a carton in the freezer. Each day I lit one Pall Mall before bed, to give cigarettes a chance. The next morning I vaped again. Each day I enjoyed more agony. One day I didn't end with a Pall Mall before bed, but merely vaped. Then day after day I merely vaped. I gave Carole my last frozen carton. Just in case, I keep one pack frozen behind the Stouffer's.

Back in the day, when my "No Smoking" essay first ap-

peared in *Playboy*, it added the joy of notoriety to the joy of misbehavior. When I printed "No Smoking" in my book, some reviewers found it amusing, some took pity on me, some found me disgusting. Now when somebody praises the frankness of my old confession, I accept their compliment hoping they never find out what I've done. It's been four years of virtue and health. My life has changed. No longer do visiting friends turn blue. Vacuum cleaner salesmen don't run away when I open the door. My grandchildren drop by and stay for a visit.

GENERATIONS OF POLITICS

POLITICS BEGAN EARLY IN CONNECTICUT. AS A CHILD I heard much of "that man in the White House." My father was as Republican as his father, H.F., who was burly and mustachioed and had already retired from running the Brock-Hall Dairy, which delivered milk from horse-drawn wagons to back porches in southern Connecticut. For years H.F. was a state representative, then a state senator. When his Republican associates wanted him to run for the US Congress, he turned them down because he had stopped school in the fifth grade. FDR went to Groton and Harvard. H.F. was an archetypical self-made man, uneducated and honorable and reactionary.

In New Hampshire the politics was just as firm. My mother's father, Wesley Wells, was a one-horse farmer in a moneyless world who had been a Democratic state legislator in a state without Democrats. Districts were so sparsely populated that voters chose a person, not a party. When I spent summers with Wesley and my grandmother Kate, I heard his stories and the funny poems he had memorized for his one-room school. Sometimes he made a noise like a Fourth of July orator about "Franklin Delano Roosevelt, who saved this country from revolution!" My grandfather's father, the Civil War veteran John Wells, was a New Hampshire Copperhead and proponent of states' rights. He hated Lincoln and left behind him an enclave of Democrats in Danbury and Wilmot, New Hampshire. My grandfather said his father was wrong about Lincoln and not much else.

THE RETURN OF DAVID

WHEN I WORKED ON MY BOOK ABOUT HENRY MOORE, I drove all over England interviewing Moore's old friends. *The New Yorker* would do it first as a Profile, giving notable attention to the sculptor as well as to the people I interviewed. No one knew me by name, but they were happy to talk to *The New Yorker.* In Scotland I chatted with Eduardo Paolozzi, the pop sculptor, and bought four of his Electric Etchings. In London I interviewed Moore's former assistant Anthony Caro. The longest and most important trip was to Cornwall and the city of St. Ives, where Barbara Hepworth lived. I needed to interview her about the 1930s and '40s, when she and Moore were rivals, living near each other in London's Hampstead. According to their friends from that time, you needed to peek into one studio and then quickly check out the other, to see who was first at a sculptural innovation.

When I talked with Barbara Hepworth, she was intelligent, competitive, cool, affectionate, and sharp-minded, full of old stories and details. We talked for perhaps an hour. I took many notes. As I stood to leave, she reached behind her and pulled out a large volume titled *Barbara Hepworth,* which she signed and gave to me. I thanked her mightily and left. Back at the hotel, I opened the book—large handsome photographs of large handsome sculptures—and glanced at the title page. She had inscribed the volume to David Hall. The ubiquitous David Hall. Of course I was happy to tuck the

book away and drive home with a joke about Barbara Hepworth. First there was a knock on the door. A messenger brought me a *Barbara Hepworth* inscribed to "Donald Hall" and would not leave without retrieving the humiliation of "David . . ."

WUK, WOIK, WORK

"WOIK! WOIK! WOIK!" MY CONNECTICUT GRAND-
father raged. In the nineteenth century everybody spoke
with a Brooklyn accent, even if they lived in Brooklyn. (Walt
Whitman wrote *pomes*.) My Connecticut grandfather praised
"woik" and repeatedly recommended it. His self-made Hall
Dairy delivered pasteurized milk to suburban back porches.
During my father's high school summer vacations, he heaved
twelve-quart crates into horse-drawn carts at 5:30 a.m. I didn't.
I was paid five dollars at the end of each August for my hay-
ing with my New Hampshire grandfather. It wasn't woik; it
was wuk. The best job of my youth shouldn't be called woik
nor wuk nor even work. In the Christmas rush, somewhere in
the 1940s, I helped to sell books in a small New Haven book-
store called Judd's. Maybe for a dollar a day? I brought my sal-
ary home in discounted books.

New Haven when I grew up was grandly mercantile,
acres of railway yards crowded with freight cars, passenger
trains transporting the world from Washington and Philadel-
phia and New York to Providence and Boston. Yale Univer-
sity didn't count, or maybe it was optional. Railway hands in-
habited three-decker houses, along with factory workers who
manufactured rifles, iron parts for steam engines, and first-
rate toothbrushes. Inconspicuous in lush neighborhoods were
the residences of New Haven's *haut bourgeois*, descendants of
the grandfathers who built factories and railroads. Miss Judd
who owned the bookstore was a formidable woman of sixty

who inhabited one of those mansions, and by day gravely presided over her enterprise with the help of one employee, a small man named Mr. Kronish. They spoke once a day. Miss Judd, arriving, said, "It's a fine day, Mr. Kronish," and Mr. Kronish said, "Yes, Miss Judd."

After a year of college I needed to find a real job for the summer of 1948 — which meant not my New Hampshire grandfather nor Judd's nor the dairy. My uncle had gone to college with the chief Yale librarian, who hired me to fill in for a sub-librarian on summer vacation. Minimum wage was 45 cents an hour, but rose to 65 cents before my first paycheck. I took a few days to learn from the man I would replace. He was a White Russian named Gregory Staritsky, reticent and so quiet he was almost speechless, skinny as an umbrella and not much taller. Before the revolution he had been a judge in St. Petersburg, then found his way to Connecticut to work in the Yale library, cataloging Uncataloged Periodicals. If Yale received, say, bundled issues of a 1942 army camp newspaper and the library found no record of it, he would fill out a library card in his czarist cursive to catalog it. With Staritsky on holiday, I tried to do the same thing. In the seventh grade I had flunked handwriting, and my cards were illegible.

Staritsky's office was a desk that sat beside another desk where Wilma Resclaw governed Duplicates. Behind Wilma was a dark vault, shelves containing thousands of books, willed to Yale, of which Yale already had a copy. Wilma told me to take what I wanted — books even cheaper than Judd's. My lunchtime exhausted itself in Wilma's vault. I picked out two three-volume editions of Thomas Hardy novels. I took home

a seventeenth-century collection (broken leather binding) of poems by Abraham Cowley. I had never read him, but I knew that he invented the pseudo-Pindaric ode. I took home a split-spined Thackeray, boring poems by Carl Sandburg, three versions of *Song of Myself,* and a ninth edition of the *Encyclopæ- dia Britannica* missing one volume. Sometime in July, Wilma told me nervously that I'd better stop.

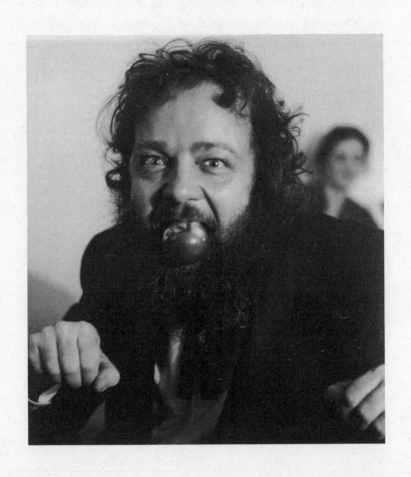

THE DICTATED PIG

IN OCTOBER OF 1974, JANE AND I ATTENDED AN EC-
centric dinner party in Ann Arbor that exploded me into
a poem. Two of my students, Ric Burns and Stephen Blos,
bought a suckling pig at the Eastern Market in Detroit to
serve at a dinner for friends and teachers. They cooked it in
the big oven at Stephen's family house following directions
from a cookbook, which told them to remove the pig's eyes
first so that they didn't burst during cooking. Ric said that cut-
ting the optic nerve was like severing a steel cord. Carrying
the cooked pig across town to their rooms, Stephen and Ric put
poles over their shoulders and dangled dinner between them.
They marched down South University Avenue, across Wash-
tenaw, and trekked through campus to their flat. When guests
arrived, the corpse occupied one end of the long dining table, a
raw apple in its mouth. I sat beside it, shrieking with delight,
and transferred the apple to my own mouth. Jane had to look
away. Stephen's camera clicked beside me, preserving the din-
ner forever.

At the table carnivorous guests devoured the pork in *fris-
sons* of ecstasy. Two centuries earlier, Charles Lamb wrote "A
Dissertation upon Roast Pig," which asserted that "there is no
flavor comparable." The next morning I ran to my workroom
and began to scribble pig lines of poetry. Out roared a tsu-
nami of images and diphthongs and obscurities. My handwrit-
ing could not keep up. I picked up my DeJur Grundig Steno-
rette microphone (I dictated letters) and recorded pig poetry,

line after line at unprecedented poetic speed. Later, of course, in illegible handwriting I revised "Eating the Pig" a hundred times until I finished it. In my lifetime of poems, it remains the only pig I ever dictated.

ROADS TO ROME

EARLY IN THE 1960S WE LIVED FOR TWO YEARS IN the English village of Thaxted, two thousand people and six pubs. The first year we rented a big old house, built in 1493, which had been altered to suit the centuries, two-story Jacobean wall paintings in the hall, an elegant Georgian staircase, wooden or plaster details everywhere illustrating English architectural history. The village enjoyed gossip about its centuries. A building beside us, sharing a wall, was rumored to have been first a monastery, then a butcher's, now a pub. Another tradition had it that houses on our side of the main street used to face the other way. A dirt lane ran along the bottom of our garden. A teacher at the elementary school consulted ordnance survey maps — created for the military in the seventeenth century, still employed during World War II — elaborately and accurately detailed with roads, streams, elevations, footpaths, and history. When the young man lined up two maps on the floor, a trace of buried Roman road turned up on a map that centered on Thaxted, and on the ordnance map of an adjoining area he found another trace of Roman road. Roman roads are notoriously straight, and a yardstick, laid from one map to another, ran directly in back of our house. The teacher took his class to a patch of unused land near our dirt lane, and three feet down found a Roman road paved with local stone and cambered for drainage.

Someone had told me about another nearby imperial remainder. An hour's drive east were the ruins of a Roman fort

called Othona, from which the last legions departed England in AD 400. I drove to see it. In a field on the straight Roman road to Othona, there were relics of more recent military history. Beside a long green strip of meadow was a crumbling concrete pillbox where Home Guards waited in 1940, World War I rifles ready for a World War II invasion. At the field's edge lay concrete obstacles that had been set out on the meadow to welcome Nazi gliders. In coastal waters fronting the ruined fort, English soldiers digging pits against German landing craft encountered a Roman seawall.

The ancient fort lifted towers, still to be seen as I visited, walls layered with the flat bricks of Rome. In a corner of Othona's ruins were the remains of a Christian church, erected in AD 600 by a Celtic priest named Cedd, later a bishop, who sailed down the English coast to convert the natives to Christianity. (Christianity had departed with the centurions.) From local wood and Othona's flat bricks, Cedd assembled St. Peter-on-the-Wall, a Roman church married to imperial Rome.

THE STAPLED WORLD

THERE WAS A LITTLE STREET TO THE SIDE OF SPRING Glen Grammar School, and sometimes a battered car parked there, a battered man standing beside it holding a canvas sack of magazines. One day he approached me, and on an autumn afternoon in 1939, when I had turned eleven, I spent two hours after school walking through my neighborhood pushing doorbells. Suburban women didn't have jobs in 1939, so it was mostly wives who opened the doors. For a nickel I offered the *Saturday Evening Post.* Many houses told me they subscribed already, and I sold only one copy. When I went home my father asked me not to peddle anything again. The family dairy delivered milk all over town. People might get mad, he told me, if they thought that Brock-Hall, which bothered them to pay their milk bills, bothered them again with young Hall flogging magazines.

After supper my family always sat reading. My father read *Time* or a Kenneth Roberts historical novel while he smoked his pipe. With her Chesterfields my mother looked at *Reader's Digest* or Thoreau or Agatha Christie or Robert Frost. Often I glanced at a copy of *Collier's.* In the thirties, forties, and fifties — before television, when radio programs offered us only Jack Benny and Fred Allen — everyone inhabited the stapled world of magazines. *Life* printed Alfred Eisenstaedt's photograph of World War II's conclusion, the sailor kissing the nurse on V-J Day. If I didn't pick up *Life,* maybe I picked up the *Saturday Evening Post*, with its immortal covers by Norman Rockwell.

When *Collier's* and the *Post* published fiction, it was mostly maudlin and adorable, but sometimes slick magazines helped out a future Nobel laureate. William Faulkner published "A Rose for Emily" in the *Saturday Evening Post*.

Television ended the static entertainment of magazines. *Collier's* died in 1957, the weekly *Saturday Evening Post* in 1963, and the weekly *Life* in 1972. When I quit teaching and went freelance in 1975, fewer stapled sources were available to support a writer, but some magazines endured for a while, and I made a living by writing for them. In the eighties and nineties, a New England monthly named *Yankee* paid me $4,000 four times a year, each time for an essay of a thousand words. *Playboy* paid an enormous sum in 1975 for my essay "Fathers Playing Catch with Sons," and *Reader's Digest* reprinted it. In the new century, fees have considerably lessened. A few years ago, a diminished *Playboy* printed three new essays of mine, and the three stipends together amounted to less than 1975's single check.

OPEN THE DAMNED DOOR

IN 2005 I PUT A NEW ROOF ON THIS HOUSE. OR rather, Steve Colburn did, overseeing a gang that kneeled precariously to remove old shingles and nail on new ones. There was always something. The next winter, snow piled three feet thick on the shingles of the barn, which dated from 1865. The old roof sagged and groaned from the snow's weight, and my helpers groaned and sagged as they swept snow to the ground. In June Steve installed metal over the spongy shingles, so that now the snows of winter slide off without being pushed.

When my great-grandfather moved here in 1865, he extended this 1803 cape by adding four new bedrooms upstairs for his kids, with a kitchen and a toolshed on the ground floor beneath them. Past the toolshed, under the same roof, a small door led to the woodshed, and beyond it to the outhouse, which had collapsed by the time Jane and I arrived in 1975. I loved the skinny maple latch that fastened the door from toolshed to woodshed, its surface shiny from a century of ancestral hands. My great-grandfather was five foot three, so I bent over when I went for wood. At first our only heat came from firewood. All winter I carried armfuls to the woodstoves, twelve loads a day, seven cords a winter.

After ten years we put in central heat, and decades later Steve took down the woodshed, replacing it with a garage. He planned to heighten my great-grandfather's low door, but I wanted to stoop for my great-grandfather's sake. (In time I stooped anyway.) It was three steps down from the toolshed

to the garage floor, so Steve put in a cement incline that eased me down. Without subjecting myself to snow or rain, I could walk from my living room through the kitchen and toolshed down to the Honda. The last thing Steve added was an electric garage door. As I bent into my new garage, I pressed a button on the wall to roll up the door, then drove to the bookstore in New London or to Cricenti's Supermarket for a jar of mustard. When you work all day doing one thing, like writing books, you need to take breaks.

Years earlier when I lived in a city, I parallel parked, but after three decades of Route 4 I had forgotten how to aim a car backward. Leaving my house for a doctor's appointment, I snapped a side mirror off. (My dealer charged $150 to replace it.) That wasn't the worst thing. One Sunday morning I felt like going to church, and it was almost 11. I hurried to the car and backed out, neglecting to open the door. The collision was minimal, but the door bulged and stuck. No car, no church. I telephoned Steve. He pulled into the driveway and lifted the door up — "brute strength," said Carole, who accompanied him — but the door would no longer close by pressing a button. Steve would come back tomorrow with tools. I missed church, but I drove to Cricenti's for a jar of pickled onions.

Two weeks later I backed into it again. Steve had to buy me a new door. My assistant Kendel — typing, bookkeeping, everything — painted OPEN DOOR above the proper button. Steve installed a pad underfoot that opened the door when I stepped on it. I forgot to step on it and three weeks later backed into the door again. Winter came, and when it snowed I remembered to open the door, but in a February thaw I knocked

it into the front yard. While Steve ordered yet another door, Kendel painted large letters on the garage's back wall in front of me as I climbed behind the wheel: OPEN THE DAMNED DOOR. Later still, she put reminders on the steering wheel and dashboard, and Carole installed a bell that tinkled as I clambered down the ramp, except that I ducked.

Then I totaled my car on Route 4 and lost my license. No more car, no more driving into the garage door! It was a relief, but I never bought pickled onions or mustard again.

CIVILIZATION

WHEN I WORKED ON MY PROFILE OF HENRY MOORE, I spent long afternoons talking with the sculptor while he sat in his studio poking at waxes or stood outdoors watching assistants alter huge reclining figures before they went to the foundry. I also interviewed several of Moore's friends and supporters, including Kenneth Clark. *Civilization* was half a decade ahead, Clark's thirteen-part BBC television series that PBS rebroadcast in the United States. When I interviewed Clark he was not yet a peer — *Civilization* made him Baron Clark of Saltwood — but he was already eminent and powerful as an art historian and museum director. At thirty he had been appointed director of the National Gallery, then during World War II he protected paintings from Nazi bombs, hiding them in Wales in the remains of Roman salt mines. Clark had been early to praise Henry Moore. The philistine English press ridiculed all modern art, and every Moore exhibition was the occasion for mockery. It helped Henry Moore that the National Gallery's director praised him in public. Clark promoted Moore's outdoor sculpture in the 1951 Festival of Britain.

In 1955 Clark bought Saltwood Castle in Kent, a stone fortress originally constructed by the Normans in the twelfth century. It was here that Thomas Becket's 1170 murder was plotted. I arrived at a nearby depot on a spring morning, and Clark himself drove me to his castle. I looked out the window at swaths of grass drifting uphill toward stately houses with acres of garden. "In England," said Kenneth Clark, "the

rich are still very rich." The Clarks lived in the one remaining tower of Saltwood. As we talked in the living room, drinking tea, around us hung pieces of the Renaissance, of the School of Paris, of Ben Nicholson, John Piper, and Henry Moore. Mrs. Clark spoke nervously of a son in New York, and appeared to want me to look after him, which embarrassed her husband. I absorbed the luxury of old French furniture as well as the splendid display of great art in a twelfth-century castle. What abundance they lived in, what centuries of stone.

As I left, I congratulated the Clarks on their castle and mentioned how fortunate it was that Saltwater had survived the Nazis' Baedeker raids. Clark told me that after the war England learned why the Luftwaffe spared the castle: Hermann Göring expected to live there.

YOUR LATEST BOOK

WHEN A WRITER HAS PUBLISHED A NUMBER OF BOOKS, there is a phrase he or she frequently hears when introduced to a stranger in the literature business. Someone busy with books — a frequent reviewer, the CEO of a publishing house, an agent, an archivist eager for manuscript — meets the writer and forgets the title of a book the writer just published, which the stranger hasn't read. Always he says the same thing: "Your latest book, I think, is the best thing you've done." One literary stranger forgot not only a title but a genre. He praised my latest novel.

WALKING TO PORTSMOUTH

MY COUSIN PAUL FENTON — HIS MOTHER WAS MY grandfather's sister — was a dairy farmer, tall and lean, a Democrat who sometimes taught agriculture at the state college and who loved to tell stories. Back in the thirties and forties, on Sundays people with cars visited people who didn't have cars. (My grandparents had Riley, the lame horse.) The older callers had grown up before radio, when living room tales or recitations had been everybody's entertainment. The middle-aged and the young paid silent attention to stories, and when the old ones died I thought the countryside would lose its stories along with its storytellers. But when Jane and I moved to the New Hampshire farm in 1975, neighbors and family still came calling in the afternoon — no work on Sunday, no church after the noontime dinner — as they had done thirty years earlier, when I spent childhood summers here with my grandparents. The mute middle-agers of my childhood had become the old storytellers.

One Sunday afternoon that first year, Paul Fenton and his wife Bertha came calling. Paul sat on the sofa across from Jane and me while Bertha spoke of their farmer son. Looking at Paul, I saw his mouth curl up at the corners. He had thought of a story. When Bertha finished speaking, Paul said, "Did you ever hear the one about the fellow, lived around here, every year in October he loaded his cart with everything the farm and family'd made all year — homespun, maple syrup, linen, maybe mittens, vinegar — and walked by his ox all the way to

Portsmouth? He sold everything from the cart. Then he sold the cart." He paused. "Then he sold the ox."

When the ox-cart man sold his ox, my spine went electric. Paul kept on and told how the ox-cart man brought presents home for his family, walking with a bundle on a stick over his shoulder. The next morning I started a short poem called "Ox-Cart Man." After six months I thought I'd finished it. The farmer walked home from Portsmouth in October, and in May began putting things together for next fall's journey. I sold the poem to *The New Yorker* and sent carbon copies to friends. The response was good, but my poet friend Louis Simpson saw something wrong. He told me to cut the last stanza of the poem, where the ox-cart man, back home, started to undertake the next autumn's repetitive shape. As soon as the farmer returned from market to his young ox in the barn, the cycle was obvious. I cut the repetitive tasks and tried the revision on *The New Yorker*. They liked it. They thought maybe there was something wrong at the end. Here's the finished poem:

In October of the year,
he counts potatoes dug from the brown field,
counting the seed, counting
the cellar's portion out,
and bags the rest on the cart's floor.

He packs wool sheared in April, honey
in combs, linen, leather
tanned from deerhide,

and vinegar in a barrel
hooped by hand at the forge's fire.

He walks by his ox's head, ten days
to Portsmouth Market, and sells potatoes,
and the bag that carried potatoes,
flaxseed, birch brooms, maple sugar, goose
feathers, yarn.

When the cart is empty he sells the cart.
When the cart is sold he sells the ox,
harness and yoke, and walks
home, his pockets heavy
with the year's coin for salt and taxes,

and at home by fire's light in November cold
stitches new harness
for next year's ox in the barn,
and carves the yoke, and saws planks
building the cart again.

Not long after the magazine printed the poem, my daughter Philippa visited us from college, nineteen years old. She was resting on the sofa as I walked toward my workroom — and a thought burst into my head: Paul Fenton's story could make a children's book! Did I think of it because I remembered reading picture books to Philippa? In forty-five minutes at my desk I wrote a draft. The next afternoon I took it up again. I needed to

imagine the ox-cart man's world, and decided he lived in 1800. There would be no trains — the railroad came through here in 1848 — and I knew about dirt roads. What did Portsmouth look like? If the farmer brought things home for his wife and children, what would he bring? (My picture book would need a wife and children.) Beside me at my desk was *A Treasury of New England Folklore.* I found a drawing of old Portsmouth, brick houses with no electric lines or telephones. Its harbor, bigger back then than Boston's, was crowded with sailing ships. The ox-cart man brought home convenient objects manufactured not in the infant United States but in England.

When someone asks me about how I write, I brag about my numerous drafts and the months it takes to revise, but writing this picture book took me about three hours. I broke the prose sentences into lines so that it looked like a poem, which it wasn't. By visibly separating phrases of my sentences, I slowed the story down.

> *and for his daughter he bought an embroidery needle*
> *that came from a boat in the harbor*
> *that had sailed all the way from England,*
>
> *and for his son he bought a Barlow knife,*
> *for carving birch brooms with*
>
> *and for the whole family he bought two pounds*
> *of wintergreen peppermint candies.*

Early in the book I listed one by one the items that the ox-cart man put in his cart, and in Portsmouth I had him remove

them for sale, in the opposite order. I made a mistake in my listing. The ox-cart man put linen in the cart but he never took it out. Schoolchildren wrote to ask me what happened to the linen. I told them it was a long walk to Portsmouth and the ox got hungry.

For the picture book I added to the story something that never would have happened. Modern kids would be shocked when the man sold his ox — as if he peddled his pet spaniel — yet selling the ox was the climax to the story. So I had the ox-cart man kiss his ox goodbye. My illustrator seized the opportunity. Years later, the children's television show *Reading Rainbow* showed its viewers the slobbering muzzle of a real ox.

When I finished the manuscript, I sent it to my literary agent, who tried the book on my regular publisher. Immediately Harper and Row turned it down. My agent tried the Viking Press and immediately they took it. Viking wrote to ask me if Barbara Cooney would do as an illustrator. Thank goodness she took it on. She visited Portsmouth, almost intact from 1800, and painted it without electric wires. In old photographs she looked at, a brace of oxen pulled a cart. She couldn't find a picture of a cart with only one ox and asked me if I could describe a one-ox arrangement. I helped her out. My cousin Freeman Morrison, long dead, had lived in a shack on Ragged Mountain and kept a beloved ox named George Washington. Freeman liked to pose for a picture with George pulling his ox cart. I mailed Barbara Cooney my 1939 Kodak Brownie snapshot of Freeman standing beside his single-ox ox cart.

The book was published one November in an edition of 20,000 copies. In January it became known that it would receive the Caldecott—the major prize for picture books—and Viking printed another 80,000 copies, a representation of the Caldecott Medal imprinted on each jacket. Sales were astonishing. I have no notion of how many copies have sold over the years. First the hardback paid not only for our groceries but for our mortgage. It also bought something even more important. Jane and I had loved living in this old family house together from the moment we moved in, but its old bathroom was deplorable. In 1938, with the help of Sears, Roebuck, my grandparents had replaced the outhouse with a cold, spidery, dusty bathroom, its bathtub the size of its toilet bowl, accessible only from the dining room. Jane and I decided that we could make a splendid bathroom where our old bedroom was, and add a new bedroom to the back of the house—if ever we had enough money. Nailed above the entrance to the new bathroom is a plaque: THE CALDECOTT ROOM.

The book came out in paperback. The text was much translated. To my surprise, a Japanese edition went into printing after printing. During the Cold War, the State Department sent Jane and me to Japan to read our poems and talk about American poetry. Therefore I was introduced not only as a poet but as the author of a children's book. In Sapporo for a poetry reading, my host had me read the book in English, then he read aloud the Japanese translation. Later it was a bestseller in South Korea, still later a continual smash hit in China. In

my late eighties I pay for a new rollator and my Lean Cuisines with South Asian royalties.

Thanks to Paul Fenton, who smiled as he remembered a story. I should have kissed him on the muzzle.

PHARMACIES AND TREASURIES

DRUGSTORES IN AMERICA USED TO BE SMALL, WITH one pharmacist. Today a CVS or a Rite Aid flourishes with an army of clerks under an acre of roof, selling canned soup, wheelchairs, sneakers, nurse practitioners, extension cords, ATMs, powdered milk, bicycles, pancake mix, canned hams, UPS, and aspirin. These mega-emporia lack a soda fountain, which old drugstores favored, where you could sit on a stool to sip a cherry Coke assembled by the pharmacist. The same chap in the old days could manufacture a chocolate sundae with a maraschino cherry on top, or under duress combine powders for your grandmother's arthritis. There was one other item that you'll never find in a Rite Aid. Books!

There used to be a lending library in every drugstore. Also you could buy a "drugstore paperback"—John Steinbeck or Agatha Christie or Pearl Buck—for a quarter or half a buck or a dollar, depending on the decade. You could even find an anthology of poetry. After I returned from Oxford to Connecticut, I found an Oscar Williams anthology in a corner drugstore, maybe *The New Pocket Anthology of American Verse*. If it was sweet and fitting to find poems next to a banana split, it was sweeter to find in a drugstore paperback poetry anthology my poem "Exile," which had won Oxford's Newdigate Prize. The canny anthologist had included the only young poet ever promoted by a *Time* photograph of "Yanks at Oxford."

There were even literary quarterlies among the drugstore paperbacks, unavailable at your local bookstore—when there

used to be local bookstores. Arabel Porter edited *New American Writing*'s semiannual unquarterly collection of highbrow fiction and poetry. Today, in the twenty-first century, in the MFA era, there are *more* poets, *more* poetry magazines, *more* poetry publishers, *more* books of poems — and *no* corner drugstores, *no* drugstore paperbacks, *no* book reviews, *no* bookstores, and *no* anthologies. We do find David Lehman's essential annual, *The Best American Poetry*, an anthology that gives us new poems but never an assemblage of old ones. The same editor put together his monumental *Oxford Book of American Poetry*, 218 poets in 1,136 pages, from the seventeenth century to the twenty-first — excellent if unwieldy, useful especially if you sit at a table in a library. (There used to be libraries.) Garrison Keillor published *Good Poems* and *Good Poems for Hard Times*, collections as modest as their titles — one man's scrapbooks of poems he likes. Late in the twentieth century only textbooks provided general anthologies. (There used to be textbooks.)

Back before literary textbooks, a century ago when I was young, Louis Untermeyer's anthologies sold in bookstores and weighed down a bookshelf. I own a double Untermeyer volume, early 1940s: *Modern American Poetry* bound together with *Modern British Poetry*, 1,218 pages. After seventy years almost every poet included, T. S. Eliot excepted, has been forgotten. Another Untermeyer anthology dominated my adolescence as much as cheerleaders did. *A Treasury of Great Poems* is 1,288 pages, from anonymous ballads and songs past Chaucer and Tennyson to W. H. Auden. When I was fourteen I found there Thomas Wyatt's sixteenth-century "They

flee from me that sometime did me seek," which I've read or consulted every season of my life. It showed the earliest embodiment I'd seen of poetry's continuous assertion that opposites are identical. Untermeyer printed not Wyatt's version but Tottel's, which regularized Wyatt's meter; growing up, I de-Tottel'd it. For each of his poets, Untermeyer wrote an introduction, frequently counterfactual but intriguing to a high school boy manic about poets and poetry. *Chidiock Tichborne wrote this poem the night before his head was chopped off! Hart Crane drowned himself jumping off a merchant ship!* And according to Untermeyer, Crane suffered from "sexual irregularities." Attracted by self-murder and sexual irregularities, I read Crane's complex and glorious lines, which sent me wading deep into dark language.

Back in the 1940s, Oscar Williams published hardbound anthologies called *A Little Treasury of Modern Poetry, A Little Treasury of Great Poetry,* and *A Little Treasury of American Poetry. Modern* was my favorite, small in its dimensions but containing 668 pages of poems. Going through it again, seventy-two years after publication, I ride on the winds of Gerard Manley Hopkins through an unchronological poetic universe to W. H. Auden. Reading it this morning, I find poems I had loved but forgotten, by poets I had loved but forgotten. The first two pages of the table of contents list Delmore Schwartz, Vernon Watkins, George Barker, Conrad Aiken, Léonie Adams, and W. R. Rodgers. If you had claimed in 1941 that Elinor Wylie would be forgotten in the twenty-first century, no one would have believed you. Again and again, rereading this book with my rollator beside me, I have looked at a poem (the

author's identity concealed until the poem concluded on the next page) and the maker's name has hurtled into my head, a poet I hadn't recalled in a decade. Dunstan Thompson! Henry Treece! It is sad and amazing that this small book contains so many beauties that are so forgotten. Of course all of us will be forgotten.

Anthologies are wonderful, anthologists maybe not. Louis Untermeyer's own poems appear in his anthologies, as repellent as the nearby poems by his wife Jean Starr Untermeyer. In turn, the *Little Treasury of Modern Poetry* prints nine bad poems by Oscar Williams and four by his wife Gene Derwood. (William Carlos Williams gets two.) At the back of this *Treasury*, and on the covers of his drugstore paperbacks, Williams printed oval photographs of his poets, sixty-two at the back of the *Modern*. Would you care to guess whose portrait ends that book? Or whose portrait resides next to Homer's on the cover of a paperback? Years ago I met both anthologists. In 1945 at Bread Loaf Writers' Conference, Louis Untermeyer spoke with me about my tenth-grade poems, clearly without having looked at them. Lucky him. Also at Bread Loaf Robert Frost talked of universities — he attended Dartmouth and quit, he attended Harvard and quit — and said, "I guess I feel about colleges the way Louis feels about women." Untermeyer married Jean Starr twice, one or two other folks in between. There's an Oscar Williams story I've told before which I must tell again. For reasons too long to recount, once at a dinner party I had to introduce him to T. S. Eliot. Startled but witty as always, Eliot said, "I recognize you from your photographs." Without irony Williams burbled that he recognized Eliot too.

Why aren't there more anthologies these days? Maybe there are no drugstore paperbacks because there are no drugstores, but why are there no new anthologies that Amazon could deliver in forty-eight hours? Years ago, a publisher commissioned me to do an anthology of American contemporaries, granting me $1,000 for permissions. Portions of that sum garnered me Robert Lowell, Richard Wilbur, Adrienne Rich, John Ashbery, Robert Bly, Denise Levertov, Frank O'Hara, W. S. Merwin — but John Berryman asked for $800 and I had to leave him out. There are no anthologies these days partly because publishers' permissions departments ask $800 for each poem. What better device might there be to sell poetry than to provide a sample? Publishers haven't noticed.

With two other poets of my generation I edited an anthology in the 1950s that became the Academic Anthology, which was contradicted and overwhelmed by Donald Allen's later assemblage from the Beat Generation. Both books were bad, ours bad in a maddeningly conventional or old-fashioned manner. For a few years there appeared to be a civil war among American poets. In due course, the Academics and the Beats dropped their weapons and became friends. One Ann Arbor morning in the sixties I woke to find an ecumenical piece of paper wedged into the mail slot of my front door. Allen Ginsberg and Gary Snyder, failing to wake me up, had improvised small poems and inscribed them to me, one on each side of a used envelope. Ten years later, when Allen had finished writing poems — to become the editor, librarian, and archivist of himself — he and I went out for a beer after I did a New York reading. Two elderly poets drank a quiet IPA together. Shortly after

Jane died I saw him last, at a Dartmouth dinner to celebrate Richard Eberhart's ninetieth birthday. I talked without pause about Jane Kenyon's death—for five years I talked about nothing else—and the Buddhist Allen calmly told me that death didn't matter.

Back in the sixties, ten years after the Academic Anthology, I wanted to make a decent and catholic anthology of new American poets—as a corrective, and in order to bring good news to a large, international audience. I thought of Penguin Books, independent and enormous, which produced great literature in paperback not for drugstores but for everybody in creation. I proposed *Contemporary American Poetry*, which contained twenty-four poets, including Lowell, Wilbur, Dickey, Snodgrass, Rich, James Wright, Creeley, Levertov, Duncan, Ashbery, and Snyder. It did not include Donald Hall. It sold not only in England and America but in New Zealand, Australia, and Canada, and it brought American poetry to the huge Anglophone middle class of India. (Twenty years later, when Jane and I traveled to India, our listeners knew American poetry by way of the Penguin.) Because English is a lingua franca, American poetry reached Latvia, Japan, Finland, Malaysia, and Texas. After eight printings Penguin asked me to do a second edition. With Jasper Johns's iconic Stars and Stripes on the cover, the second edition ran through nine more printings, adding Frank O'Hara, Gwendolyn Brooks, Allen Ginsberg, Sylvia Plath, Anne Sexton—why not Louise Glück, why not Ellen Bryant Voigt?—Tom Clark, Etheridge Knight, Ron Padgett, and one poet too many. Yes.

The Penguin was my last attempt to atone for my first at-

tempt. Later, in another country, I continued or extended the work of a man who had made the most consequent British anthology since *Tottel's Miscellany*. In England in 1936 Michael Roberts published—only fourteen years after "The Waste Land" and *Ulysses*—*The Faber Book of Modern Verse*. Readers in the United Kingdom had never heard of modernism except in philistine journalistic ridicule, and Roberts's book made a persuasive and percussive introduction to magnificent modern poetry. It began with Hopkins and Yeats and extended past Eliot and Pound to Auden and Dylan Thomas. (Roberts omitted Thomas Hardy, born in 1840.) At T. S. Eliot's behest, I made a revised edition of Roberts's Faber book. I added Geoffrey Hill, Thom Gunn, and Ted Hughes, together with other new English poets, and introduced to England the best modern Americans, from William Carlos Williams to Sylvia Plath. (I omitted Donald Hall. Eliot commended my discretion.) The book did well, even without the help of drugstores. John Berryman had learned modern poetry from the original Roberts when he was young in England. In Minneapolis a year before his suicide Berryman invited me to his flat because I had used his poems in the new edition. In Great Britain itself, my altered Faber book brought new poets to a new audience the way the original Roberts did. It even reached rural Northern Ireland and—he tells me happily—Paul Muldoon.

THE LAST POEM

POLITICS HAS CLOGGED THE AIR OF MY LIFE. OF course I vote, with my New Hampshire grandfather, for Democrats, or maybe I merely vote against Republicans. Only once did Wesley Wells neglect to vote Democratic: when the national party ran Al Smith for president. If a Catholic were president, it was common knowledge, the pope would occupy a wing of the White House. Only one time I didn't vote. I couldn't vote for Hubert Humphrey because he favored LBJ's Vietnam War. I put Nixon in the White House.

The only time I've exposed my politics in a newspaper was in 2014. Back in 2010, a Massachusetts Republican named Scott Brown beat a complacent Democrat in a special election to fill Ted Kennedy's seat in the Senate after Kennedy died. Two years later, when the seat came up in the next scheduled contest, Brown lost to Elizabeth Warren, the engagingly liberal Democrat. Two years later, in 2014, Scott Brown moved his residence to New Hampshire and ran for the Senate against an incumbent Democratic woman. He was handsome, opportunistic, rich, corrupt, moronic, and drove a cosmetic pickup truck. That year was the Republicans' Ebola Landslide. President Obama had assured the people that there would be no Ebola outbreak in the United States, and then to prove him wrong a West African man with Ebola flew to Houston and died. Scott Brown predicted that hordes of Mexican jihadists would crawl into Texas, their prayer rugs saturated with Ebola

virus. He lost the election anyway. I take credit because of my last poem, three lines I contributed to my local daily:

> *Get out of town,*
> *You featherheaded carpetbagging Wall St. clown,*
> *Scott Brown!*

The *Boston Globe* reprinted it. Somebody put it on the Internet and it went bacterial.

ANONYMOUS

LINDA REMEMBERS NAMES THE WAY BILL CLINTON does, although she does not plan to run for public office. Neither do I, which is a good thing, because I cannot remember names. Jane was as bad as I am. In Ann Arbor she decided never again to read her poems and sign books in our local bookstore, because one day she looked up from the line and saw her best friend from kindergarten, with whom she had lunch the week before, and had no idea of her name. I understood. Many's the time, after reading my poems, I've watched the line as a familiar face moved closer and closer, nameless, and felt my brain flutter into panic. Of course I *apologized* to my friend. "It's ridiculous! I can't believe it! How can I be so stupid . . . !" Stunned, my friend repeated his name, and maybe how to spell it. Each time it happened, things between us were never quite the same.

Jane and I lived in an old Ann Arbor farmhouse. Every weekend we were invited to six or seven cocktail parties. During my first marriage I went to all of them. Jane and I went to one, maybe two. (At the others our absence wasn't noticed, the cigarette smoke was so thick.) To reciprocate, Jane and I assembled and executed one big cocktail party a year. It began at 6 p.m. on a Friday or Saturday. Our guests arrived around 7. (Some came as late as 10, after attending two or three other parties.) For us, it was terror and humiliation. When anybody opened the front door of 1715 South University Avenue, he or she faced a wall with portals left and right. To the left, one en-

tered a long living room, which jogged to the right into the dining room and then to the kitchen at the back of the house. From the right-hand portal, people walked through my long, narrow workroom, then to the dining room and the kitchen. When friends coming to our party knocked at the front door, immediately Jane and I forgot their names. Each of us panicked about introductions, and each of us ran away to hide ourselves. Our guests opened the door, entered, and introduced themselves to one another as Jane and I fled by opposite routes back to the kitchen, where we bumped into each other. The circle of shame.

My handicap gets worse with old age. Linda tries to protect me. As we enter a restaurant and approach someone familiar, she whispers a name in my ear. (It has to be my good ear.) It's not Alzheimer's, not yet. My failure began early. In the cradle at two I could not remember my mother's name. "Gramma? Dad? Aunt Fred?"

NOW I LAY ME DOWN TO SLEEP

LAST NIGHT I WENT TO BED AT 10:30 AND GOT UP at 7, a good night's sleep. During the night I woke three times, but I didn't lie there twitching. When I woke I looked at the clock's illuminated hour, turned on my reading light, took a sip of water, stood up to piss in a bottle, took another sip of water, read a paragraph in *The Economist*, and went back to sleep. Each waking interlude — at 11:37 p.m., 2:12 a.m., and in the weak August light of 5:15 — took four and three-quarters minutes. I follow this script seven nights a week, sometimes two wake-ups with pees and a page, sometimes four wake-ups, and once I didn't wake until 8 a.m. I feel fine, sip some coffee, smoke an electronic cigarette, eat breakfast, read the paper, do an eighty-seventh revision, an eighty-eighth . . .

I forgot to say that at bedtime I take a pill. Many times in my life I've stayed awake all night even though I've taken a pill. Living in Ann Arbor in the 1960s, between marriages, I enjoyed the then-popular diet of Dexedrine and Nembutal. Between medications I drank bourbon, Heaven Hill at $2.50 a bottle, because I was born in 1928. (My students, born twenty years later, smoked dope and tripped on acid.) I drank whiskey because I was depressed, and whiskey made sure I stayed depressed. When the poet Ted Berrigan stole my speed, my pal the doctor scratched me another prescription.

After I married Jane, I didn't have trouble sleeping. Jane went to sleep before I did and woke later in the morning. I read for two hours after she closed her eyes, and during the

night I got up to scoop ashes from the cast-iron stove, to replace them with logs and leave the drafts shut tight. At 5 a.m. I got up again, opened the drafts, and napped until the house hotted up. I hung my nightshirt behind the stove, unhung my daytime blue jeans, made coffee, and drove to get the paper at Bob Thornley's general store. Back home I carried a cup of coffee to Jane, looked at the paper, then scratched away in my workroom, trying to write poems. Jane walked Gus the dog to wake herself up. When she returned to the house, she was still yawning. I interrupted my work to tell her either "I am immeasurably great" or "Everything I write is shit." She understood and climbed the stairs to her workroom.

When she was sick I slept surprisingly well. After she died I dreamed that she left me for another man, and I went back to sleeping pills. Even with pills sometimes I couldn't sleep. Then I discovered that sleeping pills worked better if I drank port just before I took them. When I woke in the night I drank more port. Back then I smoked Pall Malls, and once I almost burned the house down. I fell down regularly for the Wilmot Volunteer Fire Department to pick me up. So I checked into the New London Hospital for eight days. As I was going home a nurse practitioner stood stiffly before me and spoke the injunction, *"Never drink booze with sleeping pills at bedtime!"* She didn't say "booze." I think my son Andrew — sixty years old by this time — wrote the script. It was Andrew who told me not to walk around the house when I woke up. With a plastic piss bottle I had almost everything I needed. I added reading a paragraph from *The Economist*.

When I wake during the night it is always a dream that

wakes me. Sometimes I dream that I'm awake. Sometimes I dream that I'm asleep. Often it's a sepia-colored nightmare in which a body hurtles to the floor, someone I know but I never remember the name. Last night my friend Caroline Finkelstein crashed into the bedroom screaming, "Teddy killed himself!" Quickly I understood that Caroline had not burst into my bedroom. She was asleep beside Bill outside Atlanta. "Teddy" was not his name, but I knew exactly who he was: an execrable poet, an acquaintance of Caroline's. Once a brainless publisher did a book of his poems. Nobody else ever published him, which was why he killed himself.

The next night in bed I thought of writing an essay about sleeping. At 3:21 a.m. I woke from a dream about writing an essay about sleeping. I turned on the light, drank a sip of water, and read *The Economist* for two and a quarter minutes. I could not get back to sleep because I kept thinking about writing an essay about sleeping. I needed to take notes. I found a piece of paper on the table beside me but I didn't have anything to write with. Anyway, tomorrow I would not have been able to read my handwriting. I turned off the light and kept planning my essay. I couldn't stop planning so I got out of bed exhausted at 4:27 a.m. and started "Now I Lay Me Down to Sleep," which I changed to "A Good Night's Sleep." Should I change it back?

WHO I AM

MY UNCLE DICK SMART, MARRIED TO MY MOTHER'S sister Nan, was the most agreeable man I have ever known. It was in his nature, not by design, that he always smiled no matter what happened. He liked to tell stories. He was a registered Republican his whole life, because he wanted his vote to count in the New Hampshire primary. When Democrats crept into state politics, he switched parties. Never before, he exulted, had he been offered a glass of wine at a political rally.

When Jane and I settled in New Hampshire, we double-dated with Nan and Dick — one of us in her twenties, one of us in his forties, two of us in their seventies. We chatted, we laughed, we gossiped. When Jane or I published a book, Dick became our local salesman and publicist. He had no problem asking people for money, for his poets or his charities. He was cheerful, he was powerful, and he never let people feel bad if they said no. As Dick and Nan moved into their eighties, Nan had little strokes and fell down stairs. Dick fixed it so that they could live on one floor. He carried Nan from bed to bathroom, dressed her and installed her on the sofa, undressed her and lugged her to bed. Jane and I visited and talked with Dick while Nan lay on the sofa, unable to speak but apparently delighted to listen. Jane did Nan's nails. Nan spread her fingernails up to the light in a silent rapture of gratitude.

After Jane died so young, Dick drove Nan to the viewing, but Nan couldn't leave the car. Dick stood in line and afterward took me outside to Nan so that we could weep together.

Two months later Dick woke on a cool June morning. "It's cold," he said as he reached over to touch Nan. Nan was colder.

We widowers attended to each other. Dick introduced me to Stouffer's widower food, and together we went to a restaurant for Thanksgiving turkey. Slowly Dick began to fail. At first his brain was fine, but he couldn't live alone. He moved into the Peabody Home in Franklin, a three-story old folks' place, which happily never resembled a retirement community. The Peabody people let Dick keep his cat Pete beside him, cat box and cat dishes, so that Dick could talk to Pete all day. Everybody from Franklin came to his eighty-ninth birthday party before his mind started to leave him. A year later I saw him for the last time. He broke into a huge grin and squeezed my shoulder. "You know what," Dick said with good humor, "I don't have the slightest idea who I am!"

II

THE SELECTED
POETS OF
DONALD HALL

THEODORE ROETHKE

ALL MY LIFE I'VE WRITTEN ABOUT POETRY. AS I EN-
ter the last phase of it, I change my subject from poetry to
poets.

At college, I came across Theodore Roethke's work when
I picked up a copy of *The Lost Son* at Mandrake Books. I
was swept away by the greenhouse poems, small dense lyr-
ics luxurious in sound, and by the title poem with its nurs-
ery-rhyme cadences. He never did better. (His last book, *The
Far Field*, would become the best among his books, but it was
not Roethke's; it was Whitman's.) When I was at Oxford in
1953, I published in London an article called "American Po-
ets Since the War." Nobody English had read a transatlantic
poet younger than Karl Shapiro, so I concentrated on a newer
bunch: Robert Lowell, Richard Wilbur, Theodore Roethke.
After Oxford I spent a year in California, and was astonished
when Roethke telephoned from Seattle. It was December and
I was out Christmas shopping, so he talked for an hour with
my wife. He praised a poem I'd published in a quarterly, and
said that he wanted to fly me to the University of Washington
to read my poems. It was absurd. I had not yet done a book, and
had published only a few things in magazines. In my *World
Review* essay, I praised Roethke's poems, and Roethke wanted
to praise my poems back. A month later he wrote that the uni-
versity had filled its annual quota of poetry readings, and that
he himself couldn't afford me. "The Aga Khan phase is over
for this year." My wife had told me, when he first telephoned,

that he called from a hospital. I suspected a blood chemistry of enthusiasm.

Three months later, I heard that Roethke would read his poems in San Francisco, and drove from Stanford to hear him. He strode vigorously onto the stage, tall with a huge torso and skinny legs. Mr. Potato Head. He was exuberant, loud, and funny. With an extravagant gesture, he told us, "I just married a Powers model," and affected erotic fatigue. In a strong, high-pitched voice he read from *The Lost Son* and newer poems. After his performance someone announced that there would be a reception the next afternoon. I drove home, slept, and returned. I did not know that the room was dense with poets. When Gary Snyder and I later became friends—in 1954 I hadn't heard his name—I learned that he had been in the audience, along with Robert Duncan, Michael McClure, and sundry poets called Beats when they appeared in Donald Allen's anthology. Would my aesthetic have altered if I had met these poets then? No. It took me years to jettison my old tastes and habits.

I introduced myself to Roethke. He spoke of my essay, the poem he had seen, and his invitation to come to Seattle. When I had gobbled my share of him, I drove back home.

The last time I saw him, in April of 1963, I flew from Michigan to Seattle to read my poems. By that time I had published two books. Did he suggest that the university invite me? Probably. He had stayed in touch, sending me little notes with *Botteghe Oscure* offprints. He was under the impression that he was promoting himself. Because his self-serving was so obvious, it was neither effective nor offensive. (Robert Lowell was

shrewder with his strategic postcards.) Trying to sound like a Mafia don, he asked his publisher to "put in the fix for the Noble." The innovative spelling was Roethke's. Robert Frost, of all people, complained to me that Roethke was too competitive. If Roethke, Frost, and Lowell—not to mention Pope, not to mention Yeats, not to mention Homer—were all operators, operating does not suggest inferior genius.

When I was introduced at the rostrum in Seattle, I noticed that Roethke wasn't out front. I was pissed. Then he bulked into the auditorium with his handsome wife Beatrice, and my annoyance turned to terror. I was young; he wasn't. Every time I finished a poem, Roethke made a noise. Sometimes his grunts sounded derisory, sometimes approving; they were always disconcerting. When I read a brief poem about a Henry Moore sculpture, I heard Roethke's favorite movie-gangster accent curl from the corner of his mouth. "Read that one again. Read it slower this time." I did, and at a thousand later poetry readings I spoke the poem, told the story, and then recited it again more slowly. It became "the Theodore Roethke Memorial Slower Rereading."

After I finished, Roethke came up to the podium and showed me the graffito chalked on the blackboard behind me: "The teach blows horses."

At the postreading party Roethke and I arrived early. He dragged me into a corner and pulled from his pocket yards of galley. "I've got a new book coming out," he told me. "It's going to drive Wilbur and Lowell into the shadows." He handed me galleys of *The Far Field*, published a few months later, which was fine but didn't drive anybody into the shadows.

Roethke and I sat beside each other, drinking beer and mimicking W. C. Fields, to flirt with a young woman named Wendy. Across the room Beatrice looked sullen, and I thought she was crabby. I did not understand that only manics growl at poetry readings. Soon Beatrice would sit all night beside him, feeding him bottles of Heineken, listening to his ceaseless rant. That summer, Roethke swam innumerable lengths in a swimming pool, in his mania planning to compete in the 1964 Summer Olympics. He was fifty-five years old when he suffered a stroke in the pool, which killed him. In September of that year, at a London memorial for recently dead American poets, Jonathan Williams read E. E. Cummings and William Carlos Williams; I read Robert Frost and Theodore Roethke.

ROBERT CREELEY

I MET ROBERT CREELEY AT THE GROLIER POETRY
Book Shop in Cambridge when I was an undergraduate. He
had dropped out of Harvard the term before I matriculated.
We chatted happily, and I liked him until I checked out his po-
ems, which at the time sounded like E. E. Cummings. Later,
when I was at Oxford, I wrote an essay for the *World Review*
in which I derided poems by the chicken farmer from north-
ern New Hampshire whom I met at the Grolier. Creeley wrote
a fierce letter from Majorca to its editor. Twenty years later, I
found his *For Love* and read it with astonishment and joy. A
poetry exact in its images and line breaks, sublime and sensual
in the sounds it made. We met, we talked, we made up. Bob
Creeley read his poems in Ann Arbor.

When Jane and I moved to New Hampshire, we discovered
that Creeley had graduated from Holderness, a prep school not
far from our house. Holderness didn't know. When I told them
about their celebrated alumnus, they invited him to speak
at graduation. Jane and I picked him up at the Concord Air-
port. On our sofa he wrote a poem, not half bad, as fast as his
hand could move. We drove him in jeans and T-shirt to his old
school, where the faculty disguised him under cap and gown.
His graduation speech was witty, eccentric, smart, and deliv-
ered without notes. When I read my poems at his University
of Buffalo years later, we went on the town together. He flew
to New Hampshire for a surprise seventieth birthday party
that my children contrived for me. He had just done a reading

in Denver and flew past Buffalo to rent a car at the Manchester Airport in New Hampshire and drive to the party in Concord. It was a happy time. I loved him and his poems. I never saw him again. He died on the road in 2005.

LOUIS MacNEICE

WHEN I WAS AT OXFORD I MET LOUIS MACNEICE. For a while I ran Oxford's Poetry Society, OUPS, and got to choose the poets who read to us. (We paid only railroad fare. Poets charged us for first-class tickets, traveled second class, and kept the change.) Dylan Thomas said his poems; so did Vernon Watkins, Kathleen Raine, Hugh MacDiarmid, Lynette Roberts, Stephen Spender, and Louis MacNeice. When I was fifteen or sixteen I had found MacNeice's "Sunlight on the Garden" and never stopped reading him. After his early death in 1963, he was neglected, like all poets after they die. Only the critic Edna Longley attended to him. When I was in Galway a few years ago I saw the MacNeice monument, his lines inscribed in stone, and lately I've noticed expanding response and enthusiasm for his work. "MacSpaunday," the composite name Roy Campbell invented for England's 1930s poets — C. Day-Lewis, Louis MacNeice, Stephen Spender, W. H. Auden — was not only Auden. Often one poet of a generation is posthumously celebrated, others ignored. MacNeice climbs out of his grave.

He came to Oxford, he read his poems, we talked, and I saw him again. My Oxford college was Christ Church, where MacNeice was friend to a German don named Stahl. Whenever MacNeice visited the House to see his friend, he took time to walk over to my rooms. In my early twenties, it was extraordinary to open the door and find Louis MacNeice standing there.

Talking with him was not easy, as he often sat in silence, warm and present yet far away. Maybe he was garrulous only in a pub? He was inward; he was friendly. I cannot remember a word we said.

W. C. W.

WHEN WE WERE BOTH TRYING TO HAIL A CAB IN Manhattan, after the 1956 Eisenhower People-to-People meeting, I met William Carlos Williams. I began reading his poems when I was sixteen and a teacher loaned me *The Wedge*. At college I praised him in a long *Harvard Advocate* review of the first *Paterson*. Eight or ten years later we both looked for a taxi and I told him how I felt about his work. He grunted in response and stared at the gutter. Although I had grown up admiring modern *vers libre* poets — Eliot, Pound, Moore, Stevens, H.D., certainly Williams — I had recently published a poetry book that bulged with tidy metrical ditties, as modernist as pink lace borders on white linen handkerchiefs. I embodied reactionary youth. Mud from a passing bus splashed on my trousers.

JOHN HOLMES

IN 1955 RICHARD EBERHART TAUGHT ONE YEAR AT Wheaton College, in southeastern Massachusetts. At the end of spring term he sponsored a daylong poetry celebration inviting Boston poets. Every moment was crowded with readings and talks, students and teachers. I stood inside a classroom, looking out at the crowd, when suddenly I saw the poet John Holmes collapsing. His right leg jerked up uncontrollably and his torso writhed as he fell. An ambulance took him away. In two hours he was back, his old self, because an accommodating doctor had given him a drink. He told his story. He taught his classes a few hours a week. At home almost all the time, he remained in the cellar of his Medford house, working at poems, writing letters, and drinking sherry by the case. Today was the first time in years he had gone all morning without alcohol.

John stopped drinking and continued teaching at Tufts. I remember him well—soft-spoken, kind, prolific. He existed at the periphery of that era's Poetry Boston—Robert Lowell, Richard Wilbur, Adrienne Rich, Richard Eberhart, Ruth Stone, Philip Booth, Robert Frost in spring and fall. We had the Poets' Theater; we had Harvard's Morris Gray poetry readings. Anne Sexton and Maxine Kumin were John Holmes's night school students. Boston's nascent PBS station recruited John, Philip Booth, and me for a television series, talking about poetry at a table in a studio. We were listless, we were boring, we were sincere. So were our poems.

Will any of the Boston poets survive? We will hear of Rob-

ert Lowell again. Richard Wilbur in 2011 published a superb lyric in *The New Yorker*. No more. He died at ninety-six, in 2017. My literary agent could find no publisher to take on a Wilbur biography. Wilbur never killed himself or shot his wife. As far as I can tell, practically no one besides me adores his ecstatic and delicate metrical inventions. In his work he ought to survive, but probably, like most of us, he won't.

Sober John's poems continued to plod into print, patiently wrought, decorous, and dim. A final book came out. The last time I saw him before he died, we sat together in a bookstore speaking of a Boston poet recently dead. We agreed that he wasn't good enough. John went silent and then told me — shyly, with upwelling joy — that in his heart he knew that his poems would last forever.

STEPHEN SPENDER

STEPHEN SPENDER WAS THE "SP" IN "MACSPAUNDAY." When in the early 1960s I lived with my family in an English village, I made a few pounds by writing book reviews for Spender's *Encounter*. He edited the magazine together with a conservative American named Melvin Lasky. (When it was revealed that the magazine was a Cold War device funded by the CIA, *Encounter* vanished like Malaysia Flight 370.) On the side Spender accepted the editorship of a reference book, *The Concise Encyclopedia of English and American Poets and Poetry*, to be brought out by the publisher of *The Concise Encyclopedia of Music and Musicians*. As Stephen told me later, he worried about his knowledge of poetic technique. What did he know about meter? He felt overwhelmed and asked me to be his coeditor and to split the fee. I agreed. I remember nothing of making the book.

Both of us were contributors. Entries about Stephen Spender and Donald Hall were both signed "D.H." A few items were attributed to "S.S." The book was enormous, as you would expect from anything called *Concise*. It required multiple contributors, and somehow we enlisted eminent figures — Geoffrey Hill, Hugh Kenner, Thom Gunn, Kathleen Raine, John Crowe Ransom, Victoria Sackville-West, Louis Simpson, Richard Wilbur, and another fifty eminent at the time. We paid little. Though brief, the entries are remarkably thorough, impressive with impressive initials. Who approached the thou-

sand and one eminent contributors? Who chose the thousand and one subjects and categories? I remember nothing.

Something I do remember: when Stephen invited me to join him, he told me that the book would appear as "Edited by Stephen Spender and Donald Hall." A few weeks later, he told me that the publisher had a problem. Because Donald Hall was American and the publisher English, my name on the cover would inflate the US import duty. Our collaboration must appear as edited by Stephen alone, the publisher said, and Stephen in his introduction would gratefully acknowledge my assistance.

I said no.

The publisher wrote me directly. Stephen's encomium would bestow unprecedented praise. The publisher said it would be fulsome, apparently thinking that the word meant "very full" rather than "disgusting."

I said no.

The publisher arranged to meet me in London. I asked my English literary agent if she knew what the import duty would be. When we three met, Stephen was mum while the publisher continued to enlarge upon his praise-to-be.

I said no.

The publisher made a final point. "If you are listed as coauthor, the duty will double!"

"Yes," I answered. "Four percent, not two percent."

Stephen and I publicly coedited *The Concise Encyclopedia of English and American Poets and Poetry*.

• • •

STEPHEN TALKED well on any subject other than poetry. I liked to listen when he spoke about paintings and sculpture — about Matisse and the School of Paris, about Vermeer, about England's Francis Bacon and Henry Moore. One afternoon we walked together to the Leicester Galleries, where Stephen would pick up a Picasso print, the artist's proof of an etching for a translation of Ovid's *Metamorphoses*. It was Picasso in a moment of airy lines, fragile and monumental together. I admired it. Stephen said, "I believe they have another." I gaze at my Picasso now, almost sixty years later, on a wall next to my kitchen window.

We saw each other again. Frequently Stephen lectured on American campuses, coast to coast, about "Poets of the Thirties." When he flew to Ann Arbor to read his familiar talk, one of our new English professors picked him up at the airport, drove him to the Union, and carried his suitcase to his room. Stephen thoughtfully asked if perhaps the young man was tired. "Would you like to lie down?"

GEOFFREY HILL

IN THAXTED, A HUGE LATE-MEDIEVAL CHURCH —
sometimes called the Cathedral of Essex — rose from a hill
at the edge of the village. The vicar was Father Jack, a High
Church communist, fond of bell-ringing, processions, the So-
viet Union, and Greek in the prayer service. Geoffrey Hill,
who had been my best friend at Oxford years before, came to
visit us in 1960 at our fifteenth-century house. He and I had
stayed in touch by letter, but for years we hadn't seen each
other, and now the old friendship flared up. Our house had a
narrow balcony that looked over Market Street. On Midsum-
mer Eve we perched there during an annual celebration. The
Thaxted morris men entertained morris teams from all over
England, dancing together where the street widened to be-
come the market. Hundreds of men pranced wearing colorful,
bell-covered, theoretically medieval clothing.

Geoffrey knew about our morris team and had heard of
Father Jack. Inside the church, ancient stone columns were
topped with carved stone angelic faces, contrasting with dis-
torted hellish human heads screaming at the end of wooden
beams. Not that Geoffrey would enter the church at that time,
or any church. If he did, he knew that a lightning bolt would
destroy the building and him inside it. Like Cowper's castaway,
he knew that his damnation was predestined.

When I spoke with Geoffrey about Father Jack, I mentioned
that, along with his communist homilies, in his sermons he
occasionally approached the Old Religion. As we watched the

dancers, night darkened and the moon rose above us. Music from the market quieted as the morris men stopped dancing. From the church on the hill ran a cobbled path called Stony Lane—masons had lived there for two centuries of church-building—which ended across from our house. We heard faint music start from the church's hill as the midsummer night's sun dropped down. From shadowy Stony Lane down into the black of Market Street marched in single file six men, led by the vicar in green tights, playing an eerie violin. After him followed two green men with flutes, a green drummer, another green man walking with a horse's head protruding from his stomach and a horse's rump from his rear, then a last green man carrying a crossbow. Not only the vicar looked eerie. I reminded my gasping friend about ritual murder. "William Rufus told Walter Tyrell to shoot straight . . ."

We were calm the next morning over oatmeal when I suggested to Geoffrey that we walk around the fields of the village. Above Stony Lane the land rose slowly toward a disused windmill, and we climbed a narrow path among beetroot. A black cat rushed across in front of us. Geoffrey made a noise. "Don't worry," I said. "It's just the vicar."

JAMES DICKEY

SAMUEL JOHNSON NEVER GOT AROUND TO WRITING *The Lies of the Poets.* James Dickey was the best liar I ever knew. He was driving me around in Oregon and telling me about being a fighter pilot in World War II. "One day I saw two Japanese troop planes lazing along, no guns, no armor. I shot the first one down, let the other wait. They knew what would happen." Eventually he dispatched the second plane. "Killed a lot of men that day." Jim chuckled. Almost everything he said was a lie. At first I was dim enough to believe him. When he told me a story about playing college football before the war, he said that an opposing lineman addressed him with disrespect. "The next play," Jim said, "I ruptured his spleen."

When he didn't lie, he praised his wife Maxine. She's fat, he said, but—he banged his fist on the mahogany of the bar —"she's *hard*, like a table!" After Jim did a reading at Western Michigan University, the Kalamazoo poet John Woods drove him to Ann Arbor for another gig. The two men spent the night at my house, in a bedroom with two cots. As they undressed, Dickey asked Woods, "Are you homosexual?"

John said, "No."

Jim answered, "Too bad."

Jim was one of those people who cannot forgive you if you do them a favor. I heard of his work from my friend Robert Bly, who praised Dickey's poems and with his own press published a book collecting Jim's reviews of contemporary poetry.

When I first met Jim, I praised Bly's poems. I struck oil—a gusher of disdain, nastiness, and contempt. Anyone who ever did Jim a favor, and promoted his work, was subject to reprisal.

We knew each other because he submitted a poem to the *Paris Review,* where I was poetry editor. I accepted the poem with enthusiasm. Maybe "submitted" implies masochism, therefore subsequent sadism? Dickey and I wrote back and forth. He was working for an advertising agency in Atlanta, and mailed me a copy of a one-page celebration of Coca-Cola as his "latest work." Somewhere I read his poem "The Heaven of Animals," and wrote him in praise. From time to time he granted me generous words about my own stuff.

Jim himself had not yet published a book of poems. I was on a committee that picked four poetry volumes a year for the Wesleyan University Press. We had done James Wright, Robert Bly, Louis Simpson, and Donald Justice. We had published my college classmate John Ashbery. At one editorial meeting, I recommended a manuscript from Dickey. All the editors liked it. Although I praised and admired and promoted it, I preferred a new book by James Wright. We chose five poets for four slots, and Dickey was fifth. I wrote him that I was sorry. He took it well, or so I imagined.

Months later, James Wright withdrew his manuscript because he found it antiquated—metrical, crafty, reasonable—and he had begun to zap into wild, almost surreal free verse under the influence of Robert Bly. (His eventual new book was *The Branch Will Not Break.*) When Wright withdrew his collection from publication, Wesleyan cackled like a stricken hen, unable to produce an obligatory egg. To fulfill expectations,

the press required a fourth book, and Dickey had been the last poet rejected. It was I who called Dickey to give him the good news. I telephoned him at his office, and he was careful not to sound too grateful.

He never forgave me. Years later Dickey taught briefly at Reed College when its English Department flew me to the campus to talk about contemporary poets. He took me aside when I arrived and told me that these people — he didn't know why — wanted me not to read my poems but to lecture.

Often Jim Dickey, like John Berryman, was drunk when he read his poems. Sometimes he wasn't. He brought a guitar with him when he traveled, to strum at the party afterward as he chatted with the girls. Often at the after-reading party a visiting poet is surrounded by three coeds, starfuckers who expect him to choose a winner, and once Jim left the usual gathering with the usual student. Later she reported that Jim, back in the hotel room, picked up his guitar and crooned a song complaining that he warn't what he used to be.

Dickey took time away from poetry to write *Deliverance*, his best-selling novel, and to play a part in the popular movie that followed. He took the brief role of a burly country sheriff. He glared at citified menfolk who had survived a lethal assault in the woods, grunting, "Don't never come back here again."

Jim's sheriff punched out his line as if he were rupturing a spleen.

ALLEN TATE

MY RECOLLECTIONS OF SOME POETS ARE BRIEF. Allen Tate always looked grumpy.

EDWIN AND WILLA MUIR

EDWIN MUIR GREW OLD. HIS LAST BOOK WAS CALLED *One Foot in Eden,* which annoyed his wife Willa because Edwin shouldn't even *think* about leaving her. They loved each other fiercely, opposite as they were. Willa told me with pride that in their lifetimes they had avoided regular employment. "We have lived by our wits." Edwin and Willa translated Kafka together. (Willa had better German.) She was assertive, bold, worldly, tempestuous. Edwin's poems looked into another universe, hovering with a luminous tender spirit above the earth. He was confrontational only to cant. I was young and full of myself when I told him that poetry was an embodiment of the duality of . . . He snapped, "I do not listen to '*embodiments* of *dualities*'!"

KENNETH REXROTH

NEW DIRECTIONS PUBLISHED KENNETH REXROTH'S
poems, and I read Rexroth with pleasure and excitement be-
ginning in my twenties and thirties. Long poems and short, I
admired him and learned from him, his diction and his three
beats a line. His radio talks on California NPR made his opin-
ions public. A dedicated anti-academic, he bragged, "I write
like I talk." Whatever his taste or careful grammar, I kept on
admiring his poems as he kept on being nasty about me and
my eastern gang. I thought of a happy revenge. Frequently I
wrote essays for the *New York Times Book Review,* so I asked
its editor if he'd like an appreciation of Rexroth. Sincerely and
passionately and with a devious motive, I wrote an essay to cel-
ebrate the poetry of Kenneth Rexroth. I imagined the conster-
nation in California after my piece came out in the *New York
Times* — the shock, the shame, possibly the reluctant plea-
sure. Mind you, he would not thank me. His publisher James
Laughlin, mumbling out of the corner of his mouth, brought
me a meager but appreciative word.

SEAMUS HEANEY

SEAMUS HEANEY, NOBEL LAUREATE 1995, WAS MY
friend in Ann Arbor, Dublin, London, and New Hampshire.
A farmer's son from Northern Ireland, Seamus attended the
University of Belfast with Michael Longley, the magnificent
Northern Irish poet who won't get a Nobel because Seamus
did. In 1972 Heaney moved south to Dublin out of disgust for
sectarian violence. Was Seamus really my *friend?* How many
Americans thought of Seamus as a friend? People wrote cher-
ishing essays after he died — who met him only for an hour
after a poetry reading, overwhelmed by a man who was be-
ing himself. Seamus was friendly by nature, funny, kind, witty,
grossly intelligent, and a great poet. That is, he had the luck
to be Irish. I've been to Ireland six or seven times, always de-
lighted by the nation's good humor and gregariousness, not to
mention its exuberant joy in poetry. The welcoming benig-
nancy of Ireland's people — there must be exceptions, like the
Cyclops in *Ulysses* — exceeds even Italy's or India's. That Sea-
mus died at only seventy-four was the horror of 2013.

He had visited the University of Michigan to read his po-
ems in 1970 and 1974, brought by Bert Hornback, an English
professor devoted to Seamus and his work. (Bert knew Seamus
well from visits to Ireland. Bert went to Stockholm with Sea-
mus. A devastated Bert attended his funeral.) In Ann Arbor
I was stunned by Seamus's work and by Seamus. Much later,
Bert had four of us read our poems together — Seamus, Wen-
dell Berry, Galway Kinnell, and me. Saturday morning after

Friday night's reading, Bert entertained us at his house with a three-hour breakfast. After eating omelets we talked about poetry. Seamus defended Yeats against Galway's misgivings. I said some Thomas Hardy poems I knew by heart. Seamus, Wendell, and Galway each added favorite Hardys.

In 1979 Seamus, with his wife Marie and their children, visited Jane and me in New Hampshire. The two older boys were shy and quiet, but the little girl Catherine, only seven or eight, sat beside her mother on the sofa, their feet not touching the floor, the two of them singing Irish airs a cappella that filled the room with a delicate sweetness. That afternoon Seamus took a walk along the abandoned railway across Route 4. He came back holding in his hand a railway spike, which he took home to Dublin and kept in his study. When I was recovering from a cancer, Seamus sent me a broadside of his poem "The Spike." It hangs by my bed, inscribed inside an orange wooden frame.

The first day of my last Dublin visit, Seamus arranged for me to read my poems at the Winding Stair, a bookstore that took its name from a collection by Yeats. Afterward the audience and I crossed the Liffey on the Ha'penny Bridge to fill the large second floor of Madigan's pub. The crowd included every young poet in Ireland. I sat against a wall while the poets of Eire took turns sitting beside me. Across the room Seamus and Marie stood quietly, no one drooling to stand alongside the famous poet and his wife. When the Heaneys left the pub, I went off with Theo Dorgan and Paula Meehan to talk poetry and drink until dawn. The next day Seamus and Marie had me to dinner and told about driving home the night before. When

they reached their car—they had parked illegally—policemen had attached to their rear wheels something resembling a Denver boot. Marie approached the constables, who were disabling further cars, and revealed her husband's identity. The impediment was removed. Seamus said, "It was the best thing that prize ever did for me."

The next morning I saw him for the last time. He walked me through the Glasnevin graveyard, past the remains of Michael Collins and other heroes of Ireland's liberation, past Gerard Manley Hopkins's bones in the collective Jesuit plot, past the tomb of Yeats's Maud Gonne. At the pub beside the graveyard we drank our last Guinness together.

JOSEPH BRODSKY

ANOTHER NOBEL LAUREATE WAS JOSEPH BRODSKY. I met him at lunch in an undergraduate beer hall in Ann Arbor, just after he was smuggled out of the Soviet Union. The night before, I stood humiliated beside him on a platform. He said his poems in Russian with a furious intensity, a cavalry charge of poetry, to an audience of a thousand students who understood nothing except that they heard a great poet. My chore was to follow him on the platform, to say the inept translations of an Englishman, doodles of rhyme and meter that traduced Brodsky into Hallmark. Next day the professors who smuggled him out of Russia took me to lunch with Brodsky because I was the local poet. Someone must have told him that I wrote mostly *vers libre*, which he loathed, because he never addressed me. Undergraduates jerked their heads around as he bellowed the names of Soviet poets: "Voznesensky is shi-i-it! Yevtushenko is shi-i-it!" Someone at the table mentioned W. S. Merwin, who wrote free verse. He shouted, "Merwin is shi-i-i-it!"

But if Akhmatova loved Brodsky, I must love him too.

PROSAIC LAUREATES

AMONG MY SELECTED NOBEL LAUREATES, TWO WROTE prose. In September of 1956, when I turned twenty-eight, I received a letter from William Faulkner. Over the next few months, several more letters arrived, each signed with the novelist's name, each in a different handwriting. (One letter began with an unusual Faulkner sentence: "Thank you very much for your prompt reply.") In the first envelope was a photostat of a message from President Eisenhower, who asked Faulkner to organize American writers into a committee — as part of his People-to-People program, which brought together Americans of various professions "to interact with foreign counterparts to promote understanding, peace and progress." Of course it was the Cold War as ever. The accompanying first letter, written in Faulkner's own voice and signed with what may have been his actual signature, proposed to "anesthetize, for one year, American vocal cords," and to "abolish, for one year, American passports." Later, "Faulkner" announced a meeting in New York to come up with suggestions for the president. We gathered at the apartment of Harvey Breit, an editor at the *New York Times Book Review.*

His eminence William Faulkner sat in an elevated chair with a glass of brown liquid, from which he frequently sipped. I looked around the room and saw faces familiar from book jackets. There were John Steinbeck and Saul Bellow, a laureate and a laureate-to-be, and other faces that were never to become laureates' faces. There was Edna Ferber. There was

Robert Hillyer, recently the author of *Saturday Review of Literature* polemics against modern poetry. He sat between Louise Bogan and the enemy, William Carlos Williams. What was *I* doing there? Across the room I saw a figure who gave me the answer. It was Harold Brodkey, my classmate at college, who had begun to publish notable short stories in *The New Yorker*. A year earlier I had done my first book of poems. We were the Younger Writers.

Not only Faulkner drank. Bourbon was general. Faulkner began the session with a proposal to bring people from Iron Curtain countries to the United States. Let them buy a used car on the installment plan; let them go home after a year. Saul Bellow objected: on their return, they would be sent to Siberia. (Bellow was pissed off and left early. Over four decades, every time I saw Bellow he was pissed off.) Other writers recommended the distribution of books abroad and cultural exchanges — both already commonplace — and demanded that Congress approve the immigration of refugees from the recent Hungarian uprising. Unleashed by alcohol, liberated from silence, I spoke up on several issues, especially when William Carlos Williams suggested freeing Ezra Pound.

Early in the twentieth century Ezra Pound left the United States to live in London, beginning his work in poetry — because London was where the poets were. Briefly he was secretary to W. B. Yeats. From a small triangular London flat Pound wrote and published the poetry by which he educated himself, following different styles and eras, learning from Provençal poets and Chinese. He was vast in his generosity to all good new writers, to modernists like T. S. Eliot and H.D. and James

Joyce—and even to Robert Frost, who was nobody's modernist. Pound knew who was good and who wasn't. He reviewed them, he praised them, he got them published. His own poems moved past "The Return," with its dazzling sound, through the Mauberley poems, to undertake *The Cantos*. A decade or fifteen years later, Pound lurched past paranoia and mania into a political fanaticism that ended in adherence to Mussolini's fascism. During World War II, he broadcast from Rome to American soldiers his pro-Axis and anti-Semitic rants. After the war, the United States committed him to St. Elizabeths penal asylum in order not to commit him to a firing squad.

Loving Pound's poetry in spite of his madness and his fascism, I agreed with Williams's proposal. Goodness knows what else we said—tape recorders were not yet commonplace— but the meeting was generous with sincerity, silliness, booze, and posturing. After listening to hours of accumulating *dreck*, Harvey Breit praised us all and suggested that we turn things over to a subcommittee: William Faulkner, John Steinbeck, and Donald Hall.

We met the next morning in the office of Faulkner's editor at Random House. The male subcommittee arrived before the female amanuensis, so that there was time for chitchat. Faulkner and Steinbeck talked only about rifles, and agreed that the Springfield was the best. Then we listed suggestions for the president: change US immigration laws, invite Soviet citizens to come for two years to our country, and promote greater foreign distribution of American literature. When I proposed that we free Ezra Pound, Steinbeck shook his head. "No, no. It would only make them mad." Sudden enthusiasm

illuminated Faulkner's eyes. He said yes, we should free Ezra Pound, and addressing the note taker, remarked that the chairman of this committee, appointed by the president, had been awarded a prize by the government of Sweden, but America locked its best poet in jail.

It was a lesson, learned in my twenties, that humility is a necessary component of genius.

RICHARD WILBUR

A POEM BY RICHARD WILBUR ONCE APPEARED ON THE back of a package of breakfast cereal. "A Wood" decorated the recycled paperboard container of an organic granola called Absolutely Nuts.

When I was a freshman at Harvard, I read in *The New Yorker* one of Louise Bogan's adroit and decorous poetry reviews. She praised *The Beautiful Changes*, a first book of poems by one Richard Wilbur. The name was new to me, and I was stunned by the quoted poetry's wit, intelligence, and precision. "Tywater" spoke of a soldier killed in the war — Wilbur had been an infantryman in 1944 and '45, at Anzio and in France and Germany — whose "body turned / To clumsy dirt before it fell. / / And what to say of him, God knows. / Such violence. And such repose." I crossed Mass. Ave. to Gordon Cairnie's Grolier Poetry Book Shop and bought *The Beautiful Changes*. A year later, I met Wilbur when he was a junior fellow in Harvard's Society of Fellows. I was twenty, sodden with admiration, and showed him what I was trying to write. In turn he let me see drafts of poems that would appear in his second book, *Ceremony*.

He died in 2017, at the age of ninety-six, and probably looked about forty-seven years old. Shortly before he died I telephoned him and we spoke for a moment; he still sounded like Dick. His appearance and demeanor had always resembled his work — handsome, formal, warm, wry, as elegant as the curls of his italic hand, and *young*. His wife Charlee (Char-

lotte) told me about first meeting his family. When the under-graduate couple parked outside the New Jersey house of Wilbur's childhood, Charlee watched a young fellow skip down the stairs, dressed in tennis whites and carrying a racquet. It was Wilbur's father. As Charlee told me, "I knew what I was in for." She aged like a human being and died in 2007.

A year before Wilbur's first book, Robert Lowell had published *Lord Weary's Castle*, his magnificent, aggressive, iambic pentameter thunderstorm. "Wilbur and Lowell" became the young poets at the center of the universe, in line for Pulitzers, Guggenheims, National Book Awards, the prizes and honors cited in introductions at poetry readings. But reputations soar and crash, flash and fizzle — then sometimes come to life again. In 1959 W. D. Snodgrass walked naked in *Heart's Needle*, acknowledging desperate personal feeling. Four years later, Sylvia Plath wrote her devastating poems of rage and self-exposure, then killed herself. Lowell's work altered entirely, from his majestic Miltonic pentameters to the swift confessional free verse of *Life Studies*, with "Skunk Hour" that told us "my mind's not right." I remembered young Wilbur, years earlier, telling me that he was not about to spill his guts out for anybody. In the heyday of confessionalism, Wilbur's reticence became grounds for the contempt of the *New York Times Book Review*.

There is nothing wrong, I hope, in writing out of your own life. If there is, we are not permitted Wordsworth. Earlier, the seventeenth century — the greatest moment of English poetry — rarely provided a display of one's guts. Milton wrote a sonnet on his blindness, and Henry King's "Exequy" lamented

his dead young wife, but Andrew Marvell was not conducting a courtship. In "To His Coy Mistress," if we must mention something so vulgar as a *subject*, Marvell wrote about death, and not the death of anyone in particular. His poem is tetrameter couplets, always octosyllabic, that bow to each other like dandified courtiers, line by line, and within each line by medial caesura — until the poem ends with a monstrous enjambment swooping to an early caesura and a resounding conclusive rhyming terminal image.

But I write about poets, not about prosody.

My undergraduate memories of Wilbur remain most notable. Seventy years ago, he was generous to talk to an incipient poet ripe with ambition and incompetence. I brought him the draft of a blank verse poem I considered finished. Wilbur praised it but gently noted that it didn't end. (I went back to work.) Meanwhile he showed me handwritten new poems as he made them, and the way he worked astonished me. He showed me stanzas under the title "A World Without Objects Is a Sensible Emptiness" (a sentence from Thomas Traherne) that mocked and entertained asceticism. It began, "The tall camels of the spirit / Steer for their deserts . . ." When he first showed me the lines, they occupied half a page — twelve lines and a fragment, inked by a Bic, in complex rhymed stanzas with lines of differing lengths — and stopped midstanza, midline, at a semicolon. Wilbur was stuck. For a month or two, whenever I dropped by, I asked about the progress of his tall camels. They remained silent and motionless in Arabia Deserta. One day he handed me the completed poem, twenty-eight lines on the same piece of paper, continued in pencil af-

ter the blue semicolon, no word crossed out. This beautiful poem — deft, clear, witty, complex in thought, rhymed and measured with Wilbur's superlative art — took only one draft, done over months. I expressed my amazement. He told me he did a lot of walking up and down.

E. E. CUMMINGS

ONLY ONCE DID I LAY EYES ON E. E. CUMMINGS. (people are cute and write "e. e. cummings," but the signature printed on his *Collected Poems* is "E. E. Cummings.") He was judging an undergraduate poetry contest, listening to half a dozen Ivy League competitors, and his face never looked as if he heard anything. He was sullen, unsmiling, dour — possibly because he was judging an undergraduate poetry contest.

TOM CLARK AND THE LOWER EAST SIDE

TOM CLARK WAS THE BEST STUDENT I EVER HAD. AS a senior at the University of Michigan he wrote a forty-four-page paper about the structure of Ezra Pound's *Cantos*, replete with Chinese characters—Tom's back hurt from carrying Chinese dictionaries—and Greek, neatly ballpointed. What he wrote was not the last word—the last word will never be spoken—but his paper went further into Pound's structure of improvisation than anyone else had done.

Fifty years later, Tom's poems are strong, short, plain, and never worked-over. After Ted Berrigan died, Tom wrote a brief elegy which I praised. Tom told me it was "the usual fifteen-second poem." Tom has written many books of poems, many prose books about baseball. In 2006 Coffee House Press published a three-hundred-page selection called *Light and Shade*, beginning with a poem I have loved forever.

> *Like musical instruments*
> *Abandoned in a field*
> *The parts of your feelings*
>
> *Are starting to know a quiet*
> *The pure conversion of your*
> *Life into art seems destined*

Never to occur
You don't mind
You feel spiritual and alert

As the air must feel
Turning into sky aloft and blue
You feel like

You'll never feel like touching anything or anyone
Again
And then you do

Tom is first a poet but also a painter, and one of his paintings makes the cover of *Light and Shade*. He draws graph-paper lines on photographs, then identical squares on canvas, which he fills with color. When we last read poems together, in San Francisco, 1989, Tom hung a painting on the wall behind us, an oil of Marilyn Monroe stretched out in languor. Fifty-one percent of the audience was not amused. Returned to New Hampshire, I commissioned Tom to paint a portrait of Reggie Jackson for Jane, who was a baseball fan. Two decades after her death, Reggie still hangs laughing and triumphant in her vacant study.

When he graduated from Michigan, Tom won a fellowship to a Cambridge college where he worked with Donald Davie, a professor and poet friend of mine. (Davie wrote me that Tom was the best student he ever had.) Later, in Paris, at the Shakespeare and Company bookstore, Tom found a magazine — wit-

tily titled *Adventures in Poetry* — assembled by second-generation New York School poets, including Ted Berrigan and Ron Padgett. In England Tom had been dropping acid every other day, and now he undertook a new obsession. He emigrated to join the East Village and its poets: Ted Berrigan and Ron Padgett, Anselm Hollo, Joe Brainard, Peter Schjeldahl, Anne Waldman, Larry Fagin, and ... you haven't heard all these names? The editor of *The New Oxford Book of Seventeenth-Century Verse* suggests that minor poets tell you more about an era than major poets do. It's possible that these poets are not so minor as Andrew Marvell. A book dealer tells me that in the rare book market they are hot.

The second generation of New York poets, after Ashbery and Koch and O'Hara, began when Ron Padgett emigrated from Oklahoma first to Columbia University and then to the Lower East Side. When Padgett was still in his Tulsa high school, he edited a poetry magazine that inspired Ted Berrigan, an army veteran temporarily in Oklahoma on the GI Bill. Ted left Tulsa for Manhattan with Ron, Kenward Elmslie, and Joe Brainard. This group made magazines like the *Adventures in Poetry* Tom had discovered in Paris. Along with other East Village publications, it was mimeographed on legal-sized white paper, the pages stapled together.

Ron and Ted together brought out a book called *Bean Spasms*. Joe Brainard wrote *I Remember*, a long poem, followed by *I Remember More*, and more, and more ... "I remember chicken noodle soup when you are sick." These poets' public space was St. Mark's Church, where they did frequent and multiple readings. Anything could make an East Village

celebration. Ted Berrigan's wife was Jewish, so Ted held a Seder. Some of us drank Manischewitz, others a generic dry red. Joe Brainard was an artist before he became a serial rememberer, and illustrated the poems of his friends. Another artist to the gang was George Schneeman, who sent me the annual gift of a Schneeman image bearing a pasted 5-cent year-by-month calendar. Over my Glenwood range, I nail a red-checked shirt wearing 1968's lumpy January on top of eleven further months. In the bathroom I hang two of George's collages, four inches by six, one foregrounding the white-hatted Old Dutch Cleanser icon. Once I watched a squad of East Village poets gather to frame George's collages, passing around aluminum struts and cardboard mats.

In 1969 Tom Clark, Ted Berrigan, and Ron Padgett flew to Ann Arbor for a three-headed poetry reading. On campus in those years, performances of poetry filled up cafés and warehouses and rectories. Elsewhere were happenings, teach-ins, Poets Against the War, fucking in the streets, marches on Washington, acid, pills, and the Pill. I was between marriages, hanging out with students who tried to convert me from bourbon to pot. Before the three-headed reading the East Villagers toked me a cigar joint, and on our way to the auditorium we stopped at a pizza place for supper. It was the best pizza I had eaten in my entire life.

When Jane and I moved to New Hampshire, Larry Fagin and his girlfriend visited us and sat on the living room rug, gazing with open mouths at the TV set above them. I bump into East Village poets even today. When I see Peter Schjeldahl's elegant art criticism in *The New Yorker*, I remember a

squalid splendid flat on the East Side. Not long ago, I ran into the best poet of them all, Ron Padgett, when I read my stuff in Vermont, where he spends the summer. Padgett is a superb translator of French poetry, but he is not only a translator. In *Poetry* Yasmine Shamma reviewed Ron's eight-hundred-page *Collected Poems*. Mostly I am too feeble to lift the book, but early in the day I struggle and manage.

Poetry's young new editor recently told me in a letter that he had just bought two poems by "old Tom Clark." Ted Berrigan was the East Villager I knew best after Tom. One term at the University of Michigan I arranged a teaching job for him. I won't forget his arrival at the English Department's September cocktail party. His hair flowed past his shoulders down his back, and above his red corduroy pants a bright yellow shirt billowed under a sumptuous green velvet vest. Tenured professors wore three-piece gray flannel suits while the department chairman stared at Ted aghast. Ted stayed for a while at my house, in a room upstairs, and when he moved out he apologized. "Sorry I took your pills. They made me great poems."

JAMES WRIGHT

IN MY MID-TWENTIES, EDITING POEMS FOR THE *PARIS Review*, I scouted the best younger poets by reading literary quarterlies. Especially I looked for poets as young and as new as me. In 1955 I wrote James Wright soliciting his work. He sent me a bunch for the magazine, and our friendship began. After many letters exchanging many poems, Jim and I met in the flesh at a Modern Language Association conference when both of us were looking for university jobs and our poems were largely unknown. At a hotel bar we were drinking beer when an acquaintance of mine dropped by. I'll call him Zach. He is long dead, and I remember only his repeated *shtick*. I introduced him to Jim the poet, and Zach stuck out his hand while he transformed his face into a visage of extravagant awe. "I, I know . . . *I know . . . your work!*" Jim fell for it, like all of us.

Jim died when he was fifty-two. A few years later I introduced his posthumous complete poems, *Above the River*, talking about the work that I loved and about Jim's scattery life — poetry, depression, the army, college, depression, marriage, prize-winning poems, fatherhood, depression, alcoholism, divorce, emptiness, remarriage, depression, early death, unforgettable lines and stanzas. Drunk or sober, exuberant or depressed, Jim was always passionate about literature. He knew page after page of Dickens by heart. When he taught at the University of Minnesota, on weekends he often took a bus three hours to a tiny town called Madison, at the edge

of South Dakota, where Robert and Carol Bly lived without electricity or running water. Robert edited *The Fifties,* which became *The Sixties,* and for one issue *The Seventies,* while he translated Neruda and Trakl and constructed his own inventive, dreamlike poems. In his magazine he promoted expressionist, almost surrealist work, while Jim was still writing crafty, straight-shooting, metrical quatrains. Jim understood from Robert that his work was old-fashioned.

The Blys encouraged Jim's visits, but Jim could be an annoying guest. He drank all night, taking part in literary argument, and in the morning forgot everything said. Carol Bly was one of nature's practical jokers. Robert came from Norwegian farmers, and dinner had to include three food groups. Beef was expensive, so Carol made meatloaf using Pard — canned dog food. She dealt with Jim as inventively as she did with Robert. In the winter Jim slept in the sub-zero chicken house, and woke to stand over the Blys' wood-burning kitchen range thawing out his removable teeth, frozen in a tumbler. One summer night after Jim fell asleep, Carol slipped into the chicken house and substituted for Jim's dentures century-old false teeth, yellow fangs wobbling from faded gray vulcanite gums, which she had found in a junk shop. In the morning Jim mumbled, "I thought I had slept for a hundred years . . ."

After several years of visits to Madison, Minnesota, Jim's *The Branch Will Not Break* appeared — free verse with extravagant images and metaphors, a manner or strategy suggested by Spanish and Latin American modernists. Image and narrative leapt from topic to topic, illuminating the one by contrasting the other. I think of his "Lying in a Hammock . . ."

After a visually exact chronicle of the natural world, the poem ends, "I have wasted my life"—and we see how he said what he meant. His imagination expanded before our eyes, even by way of a line break: "I would break / Into blossom." Learning from Bly, doing Bly better than Bly, Jim shocked the poetry universe with his new work, his best work.

Afterward, now and then, Jim sent me an old-fashioned, reasonable, narrative, metrical poem. "Don't tell Robert," he said.

Jim stayed with me in Ann Arbor when we were both between marriages. We sat across from each other talking and drinking. I noticed something wrapped on the table beside Jim's chair, and with my usual bossiness told him, "Eat your sandwich." Obediently he unwrapped it and spoke in mournful measure. "Every morning I wake with a cold hamburger beside me."

III

NECROPOETICS

EVERY FIVE YEARS OR SO, A NATIONAL MAGAZINE publishes an essay proclaiming or lamenting the death of poetry. All my life, on the other hand, I have explored the poetry of death. Now, as I read so much about dying and palliative care, my thoughts always slide back to my wife Jane Kenyon's leukemia and premature death. Between us there was such a radical difference in age. We almost avoided marriage because her widowhood would be so long, and today it is twenty-two years since she died at forty-seven—while I approach ninety.

When I was a high school freshman and decided to write poems my whole life, Jane was minus five. She finished primary school in 1957, when I took a teaching job in her hometown of Ann Arbor. With me came my wife Kirby and my son Andrew, my daughter Philippa arriving two years later. The marriage crumbled and broke after a decade, and I endured wretched years of booze and promiscuity. To our endless good fortune, Jane and I found each other and, in 1972, entered the judge's chambers. Three years later I quit teaching and we moved to New Hampshire. My children as they grew up came east for education and remained here as our neighbors. In my twenty New Hampshire years with Jane, everything in my poetic history happened again, this time to Jane: her first poem printed here, her first poem printed there, her first book, her second, an NEA fellowship, her third book, a Guggenheim,

her fourth book. Multiple poetry readings followed her publications, as her reputation elevated and spread.

When we knew for certain that she was about to die, she told me the whereabouts of unpublished poems, and I read them for the first time. They were dazzling, and I faxed them to *The New Yorker*, which afforded her poems their biggest audience. When we heard back a few days later, Jane's eyes were open but she couldn't see. She had stopped speaking, but her oncologist said that she could still hear. I told her that Alice Quinn was taking seven poems for *The New Yorker*. If you are never going to see or speak again, what do you think when you hear such a thing? Not much.

POETRY BEGINS with elegy, in extremity, as Gilgamesh laments the death of his companion Enkidu, watching worms crawl out of Enkidu's neck. What horror we embody in reciting death's progress. Homer sings of heroes as they die in battle, and Priam weeps to see his son Hector's body dragged around the walls of Troy. Virgil follows Aeneas from the graveyard of Troy to the founding of Rome, Dido's pyre flaming on the way. In the fifteenth century, poetry departed England after Chaucer and emigrated north to the Scots, where William Dunbar wrote his elegy for the makers — in Greek, a poet is a "maker" — and grieved over twenty-five dead and dying Scots poets. Not a line from these poets remains. In "Lament for the Makaris" Dunbar writes:

> *I that in heill wes and gladnes,*
> *Am trublit now with gret seiknes,*

And feblit with infermitie;
Timor mortis conturbat me.

He hes done petuously devour
The noble Chaucer, of makaris flour,
The Monk of Bery, and Gower, all thre;
Timor mortis conturbat me.

He hes Blind Hary and Sandy Traill
Slaine with his schour of mortall haill,
Quhilk Patrik Johnestoun might nocht fle;
Timor mortis conturbat me.

The refrain translates as "The fear of death confounds me," but "*conturbat*" is more violent than "confounds." When I learn that Blind Harry and Sandy Traill are dead, the fear of death shakes me as a dog shakes a rat. A few years later, in Shakespeare's English, not in Scots, Hamlet dies, Lear dies, Macbeth dies. In Milton's "Lycidas," the vowels of lament are golden, as erotic in sound as *Paradise Lost*, but the grief is formal not intimate, literary not literal. Tennyson's *In Memoriam A. H. H.* embodies grief before resolving it by theology. The profoundest or most mournful American lament is Whitman's for Lincoln, "When Lilacs Last in the Dooryard Bloom'd." A great elegy from the seventeenth century, rooted among the best poems of the English language, is Henry King's "The Exequy":

Accept thou Shrine of my dead Saint,
Insteed of Dirges this complaint;

And for sweet flowres to crown thy hearse,
Receive a strew of weeping verse...

His bride has died in her twenties: "Thou scarce had'st seen so many years / As Day tells houres . . ." In almost a hundred lines, tetrameter couplets hurtling with a passion of grief, King looks ahead to his own death and inevitable reunion with his bride. It is not compensatory.

Sleep on my Love in thy cold bed
Never to be disquieted!
My last good night! Thou wilt not wake
Till I thy fate shall overtake:
Till age, or grief, or sickness must
Marry my body to that dust
It so much loves; and fill the room
My heart keeps empty in thy Tomb.

When Jane and I lived here together, we suffered the deaths of dear friends and cousins. Edna Powers, granddaughter of my grandfather's brother, was a parishioner of the South Danbury Christian Church. Large, affectionate, warm, outspoken, Edna died in her fifties on the operating table at the Franklin Hospital when the surgeon opened her body to find a universe of cancer. We wept, we wept, we wept. To Jane I read Henry King's "Exequy" aloud.

When death, as public as a president or as private as a lover, overwhelms us, it speaks itself in elegy's necropoetics, be the subject a twenty-five-year-old bride or Enkidu or Edna Pow-

ers or Blind Harry or Abraham Lincoln or Jane Kenyon. When Jane died, "The Exequy" kept me company again.

WHEN I was nine or ten, generations of uncles and cousins went into the ground. At Great-Aunt Jenny's funeral, Great-Uncle George felt a pain in his back. We buried him two months later. I woke in the night hearing myself declare, "Now death has become a reality." At twelve my first poem was "The End of All." As late as 1975, ecstatic as I returned to boyhood's New Hampshire farm, I remembered its horses and finished a poem by burying them. At one point I decided that if we flattered death it might spare us, so I wrote "Praise for Death." Of course death didn't belong only to horses. Between my two years at Oxford, I returned to the United States to marry my first wife. My New Hampshire grandparents couldn't attend the wedding — the year before, my grandfather suffered malfunction in a heart valve — and after the wedding, before sailing to England, we had only a day to drive to the farm. I had spent my childhood summers there, listening to my grandfather Wesley Wells's stories, haying with him every afternoon, at dinner eating my grandmother's chicken fricassee or red flannel hash. My grandfather was my life's center, the measure of everything. My bride and I arrived the day after our wedding, she met Kate and Wesley, we ate a hen fresh from the henyard, we chatted, and when Kirby and I started upstairs for sleep, Wesley could not help but tell a funny story. The night he and Kate married, Kate's cousin Freeman had wired a cowbell to their bedsprings.

Three days later we boarded the *Queen Elizabeth* for Eng-

land and Oxford. In March came the airmail letter from my mother — transatlantic telephone calls had to be scheduled — which told me that my family was burying my grandfather. In our Banbury Road flat there was a room where I worked on poems. For a week, for a month, for a season, I sat at my desk writing "Elegy for Wesley Wells," fiercely iambic, making him the high point of the dying world. "Soon I will leave, to cross the hilly sea / And walk again among the familiar hills / In dark New Hampshire where his widow wakes."

TWO AND a half years after our wedding, our first child was born. When the baby turned out to be a boy, we named him after my father and me, Donald Andrew Hall. We would call him Andrew. When mother and son came home from the hospital, my wife's breastfeeding was insufficient. Every night with pleasure I gave him his 2 a.m. bottle. Every day I worked on a poem called "My Son My Executioner." *The New Yorker* published it, an anthologist put it in a college textbook, teachers assigned it, and for decades textbook anthologies reprinted it. I was the fellow whose son walked him to the gallows.

My son, my executioner,
 I take you in my arms,
Quiet and small and just astir
 And whom my body warms.

Sweet death, small son, our instrument
 Of immortality,

Your cries and hungers document
Our bodily decay.

We twenty-five and twenty-two,
Who seemed to live forever,
Observe enduring life in you
And start to die together.

In Andrew's first autumn, Kirby enrolled for her senior year of college. We had married after her junior year. For a year I fed Andrew breakfast in our flat while his mother took classes and studied or wrote papers at the library. I gave him his bath, played with him, changed his diaper, put him down for his morning nap, changed his diaper again, walked around with the baby on my shoulder, and gave him another bottle. At noon Kirby relieved me.

MY FATHER turned fifty-two on December 6, 1955. He died of lung cancer two weeks later, and we buried him on Christmas Eve in the Whitneyville Cemetery in Hamden, Connecticut, a block from the house he grew up in. During his seven months of dying, I lived two hours away and drove to see him once a week. He could not speak outright of his approaching death. In a low voice that cracked and shuddered, he murmured, "If anything . . . should happen . . . to me . . ." I turned twenty-seven as he was dying. Week after week I watched as his skin paled, he grew frail, he grew frailer, he sank silently down and down. My mother Lucy rubbed his head, rubbed his

head, rubbed his balding head. He died a few hours before my weekly visit. The last time I sat with him alive, I thought that every breath might be his last. Not yet had I observed brain-stem breathing — three quick breaths, a pause, and a last long breath — which I would watch as my ninety-seven-year-old grandmother died, and twenty years later my wife.

Everyone was there for my father's funeral. My grand-mother took the train from New Hampshire, from the tiny de-pot of Gale, three-quarters of a mile south of the farm. She wore her Sunday black dress. Kirby brought Andrew, and I re-member him playing with a plastic toy telephone. My mother Lucy, a widow at fifty-two, hadn't had a night's sleep for many months. She would live until almost ninety-one without dat-ing another man. It was cold, Christmas Eve, as we buried him in early darkness on almost the shortest day of the year.

For many months afterward I worked on "Christmas Eve in Whitneyville." I used Thomas Gray's stanza if not the char-acteristic rhythms of "Elegy Written in a Country Church-yard." It was the best poem I had written, and it lamented that my father never did what he wanted to do. "'The things I had to miss,' you said last week, / 'Or thought I had to, take my breath away.'" I decided that for the rest of my life I would do what I wanted to do. I sent the poem to the *Kenyon Review,* the prestigious literary magazine of its day, and John Crowe Ran-som accepted it, calling it "pious."

FORTY YEARS later, my poems in *Without* resonated with Jane's pain of dying and with my pain of witness. Jane's own

necropoems began earlier, when her father died. During his cancer she and I flew from New Hampshire to Michigan and with her mother took turns staying up all night beside him. Three years after her father died, Jane's poems encountered my almost-death. I lost half of my liver to cancer. My surgeon said that after such an operation a man of my age had a thirty percent chance of living five years. We wept driving home from the hospital. Soon she showed me her poem "Pharaoh" as I lay in bed recovering from the surgery.

> *I woke in the night to see your*
> *diminished bulk lying beside me —*
> *you on your back, like a sarcophagus*
> *as your feet held up the covers. . . .*
> *The things you might need in the next*
> *life surrounded you — your comb and glasses,*
> *water, a book and a pen.*

"Is it all right?" said Jane, bending anxiously over me in the bedroom's half-light. Jane had the habit of repeating a difficult sentence with a heavier emphasis. She said again, "Is it *all right?*" "It's a wonderful poem," I said as I finished it. I paused and added that yes, it was remarkable to read of my own death; I was so used to writing about other people's. Jane bought a portable massage table and set it up in the bedroom. Every day for a year she massaged the cancer out. When I was still skinny with chemotherapy, she showed me a draft of "Otherwise," beginning:

> *I got out of bed*
> *on two strong legs.*
> *It might have been*
> *otherwise. I ate*
> *cereal, sweet*
> *milk, ripe, flawless*
> *peach. It might*
> *have been otherwise.*

As she showed me the poem, it ended two stanzas later: "But one day, I know, / it may be otherwise." I wonder if Jane suspected that I would change a word; frequently we revised each other. I crossed out "may" and wrote "will."

And so it was, but not as we assumed.

WHEN A New York composer twenty years later set several of my poems to music for tenor and piano, he mentioned my name as he visited the medical school at Columbia. "Oh, yes," a doctor-teacher told Herschel Garfein, "we use him." After I published my book of poems out of Jane's death, many medical schools used me. Sometimes they invited me to read to their students and answer questions. Twice the University of Utah flew me from New Hampshire to Salt Lake City to read from *Without* at its school of medicine. I told student doctors about our oncologist Kris Doney in Seattle, where Jane had her bone marrow transplant. Dr. Doney adhered to Jane's suffering and to my own as husband and lover. After the successful transplant and our return to New Hampshire, when Jane's leukemia outwitted her new marrow, Dr. Doney flew cross-coun-

try for Jane's funeral. She did it for us who had become one person in the disease.

In the past, stories of dying and death resided outside medical discourse. Death was medical failure, and doctors concentrated on the not yet dead. But in the second half of the twentieth century, human attention turned itself to the only event common to everyone. In 1967 in England, the physician and social worker Cicely Saunders founded the first true hospice, not to prolong life but to attempt to support and comfort the dying. Death and grief became subject to intimate analysis in Elisabeth Kübler-Ross's *On Death and Dying*. Gradually we have equipped ourselves to think and talk about dread and terminal suffering. Palliative care has become a medical specialty, and death the subject of lyric as well as narrative attention, even painterly, as in Ferdinand Hodler's images of his dying mistress. It wasn't surprising that Columbia used me in its medical school, which offers a master's degree in narrative medicine, appropriately directed by Dr. Rita Charon. A doctor at the Yale medical school, Anna Reisman, quoted on NPR the last poem Jane wrote, "The Sick Wife," saying that doctors still "don't really know what patients are going through."

Necropoetics includes necromemoir. The young neurosurgeon Paul Kalanithi wrote *When Breath Becomes Air* as he was dying of cancer at thirty-six. Smitten with multiple tumors, in his agony he continued to operate on patients with brain cancer. He and his wife conceived a baby despite his condition. While dying he made his suffering into a brilliant and devastating memoir.

Every season adds to the literature of dying. Ira Byock wrote

Dying Well. Atul Gawande's *Being Mortal* was a bestseller for a year. In the *Journal of the American Medical Association*, Dr. Jed Myers, a psychiatrist who lives and works in Seattle, wrote "Poetry's Company" after he watched his father die over six months of glioblastoma. He quotes from my poems about Jane's death, then from my friend the poet Christian Wiman, afflicted for decades by his own multiple cancers. Myers ends by addressing the medical profession: "I commend to you, fellow physician, the pragmatically useless treatment called *poetry*, whereby we might leave our patients less alone when our medicine leaves us all alone."

JANE'S EARLY life had been rural and quiet, just outside the bustle of Ann Arbor. Her parents were freelancers as musicians, and she grew up surrounded by music in a house full of books. In junior high she started writing poems and keeping a journal. She enrolled in the University of Michigan, flunked biology, dropped out, took a job, returned to major in French, studied to be a teacher, switched to English and took my course in Yeats and Joyce. (It was a large lecture course, and I didn't know her.) Next year she applied to take my poetry workshop, and most of the poems she submitted were slight and fantastic, a habit of the moment which Robert Bly called "light verse surrealism." Yet one of her poems was darker and stronger, resembling her later work. She wrote of trying to capture the attention of her sick grandmother, approaching the hospital bed "like the young nurse with the needle" (see page 21 of her *Collected Poems*). Her embodied caregiving image brought her into my class and altered two lives forever.

In the first three years of our marriage, when we stayed in Ann Arbor, she worked on poems mostly when I flew out of town to do poetry readings. When I was at home my presence appeared to inhibit her. In New Hampshire for the first time she worked on poems every day. Here she had no job, no local past or friends. To confirm ourselves, we had each other, we had our house, we had our landscape, we had my cousins in the small white clapboard church — and we had the lyric labor and passion of our lives. We devoted every hour of every day to each other or to making poems. She wrote tentatively about inhabiting *my* place, *my* history. She saw, or imagined she saw, my ancestors haunting our kitchen, and her poems attended to possibilities of alienation. She floated in space like an astronaut detached from the mother ship — or was she attached? She found in the shed a woman's long gray hair.

A close friend and poet from Ann Arbor had moved to Boston, a woman Jane's age who belonged to the Alice James Poetry Cooperative. Joyce Peseroff recruited Jane, and the cooperative published Jane's first book, *From Room to Room*, in 1978 — the effective beginning of her life in poetry. Then Jane and Joyce started a poetry magazine, *Green House*, addressing their generation of young poets. It was eight years before Jane did another book, second of the four books in her lifetime, but as she published new poems in magazines, she came gradually to national attention. I remember when *The New Yorker* bought its first Jane poem, "Thinking of Madame Bovary." Her second book, *The Boat of Quiet Hours*, was ready for publication years before it appeared, and its delay only made it a larger and richer book. Jane's friend the poet Tess Gallagher

worked to place it with Tess's publisher, Graywolf Press. Graywolf was small and brilliant, edited by Scott Walker in Port Townsend, Washington, and brought out *The Boat of Quiet Hours* in 1986. *Let Evening Come* followed in 1990, *Constance* in 1993, the posthumous *Otherwise* in 1996.

Over these years Graywolf Press expanded into a major nonprofit literary publisher in St. Paul, Minnesota. Jane's designer Tree Swenson stayed the same, to Jane's benefit and joy. Tree beautifully executed covers for all of Jane's books, including *Otherwise*. When she and her husband Liam Rector visited us in April 1995 to say goodbye to their dying friend, on the last day when Jane could leave her bed, Tree asked her if she had any notions about a cover. Almost speechless, Jane picked up a volume from the living room floor and awkwardly fingered through it. It was a collection of impressionist paintings of gardens, which a friend had mailed her at the Seattle hospital. In her frail dying voice Jane spoke of what she looked for, then found the page and the image. She pointed at the print of Gustave Caillebotte's *Le Jardin Potager, Yerres*. Tree borrowed the book and used Caillebotte's painting for Jane's jacket. When she and Liam returned a week later for Jane's funeral, Tree displayed a mock-up of *Otherwise*.

THE YEAR when Jane published her first book, I brought out my seventh. That's what she had to put up with. *Kicking the Leaves* was a breakthrough for me, deriving its force from the ecstasy of marrying Jane and the life-changing departure from university teaching to freelancing in New Hampshire. My bland first collection in 1955 had been overpraised. When

the second book followed, and the third, the fourth, the fifth, and the sixth, no one paid much attention. (Just before *Kicking*, I published a prose reminiscence of older poets. Reviewers who praised that book found it ironic that the author of *Remembering Poets* had once been a promising poet.) *Kicking the Leaves* remained around for decades, reprinted many times, selling in the end many more copies than my first six titles together. With my marriage to Jane and my return to old sources I had found myself as a poet, and my next books carried me forward through *The One Day*.

Meantime, Jane's reputation bloomed in high color in poetry's garden, poem after poem and book after book. Three or four times a year she workshopped with Joyce Peseroff and another young woman, Alice Mattison, a novelist who also published short stories in *The New Yorker*. Jane's parents and brother had always avoided artistic ambition for fear of failure. She escaped the family fate by collaborating with vigorous friends, avid for excellence and eminence, who permitted themselves to compete. Each time Jane returned from her three-woman workshop, she was triumphant in her energy. I watched her excitement and progress with joy and envy.

For decades she and I had written what could loosely be described as the same sort of poem. It was free verse, mostly short poems in lines of largely similar length, delicate rhythms with forceful enjambments and an assonance of diphthongs. My earliest poems, long before Jane and I knew each other, were rhymed and metrical. Ten years after Jane's death, out of love for Thomas Hardy and the seventeenth century, I wrote metrical poems again, many of them about Jane, but in the long

middle of my life I improvised, like Jane, a sensuous rhythm without meter. Our work had been different enough — people knew us apart — but we belonged together to a stylistic consensus.

As Jane moved from glory to glory, the language of my poems began to diverge from hers. In one lengthy collection my poems became more ironic and more ingenious in structure, but less dark and less sensuous. A subsequent, still weaker book assembled brief plain poems of anecdotal reminiscence. It appeared just after Jane died, and compassionate reviewers attributed its mediocrity to my anguish. Over the years I have understood how or why my poems altered and deteriorated. Working beside her, I felt overwhelmed as I read "Let Evening Come" and "Briefly It Enters, and Briefly Speaks." Extravagantly I admired the embodiment of her struggle with depression in "Having It Out with Melancholy." One summer after a neighbor farmer finished cutting our fields, she handed me "Twilight: After Haying."

> *Yes, long shadows go out*
> *from the bales; and yes, the soul*
> *must part from the body:*
> *what else could it do?*
>
> *The men sprawl near the baler,*
> *too tired to leave the field.*
> *They talk and smoke,*
> *and the tips of their cigarettes*
> *blaze like small roses*

in the night air. (It arrived
and settled among them
before they were aware.)

The moon comes
to count the bales,
and the dispossessed —
Whip-poor-will, Whip-poor-will
— sings from the dusty stubble.

These things happen . . . the soul's bliss
and suffering are bound together
like the grasses. . . .

The last, sweet exhalations
of timothy and vetch
go out with the song of the bird;
the ravaged field
grows wet with dew.

Such sensuous beauty. As the dew falls the soul eases into bodily receptiveness. These devastating enactments of Jane's art became daily events. The emotional abundance of her language climbed to the summit of literary achievement, the pupil exceeding her teacher, and I began to make my poems as unlike Jane's as I could manage.

WHEN JANE was diagnosed and put to bed in Dartmouth-Hitchcock, an hour north of our house, I rented a motel

room next door and spent every day with her. I took notes in brief lines of verse — observations, anecdotes, humors, terrors. I found and used a few of these lines later when I assembled my poems about her death. Only six months into leukemia, I drafted the poem "Without" in the present tense. Her first remission was failing in the New Hampshire hospital as we waited for a stranger's bone marrow match and a flight to Seattle. She had been diagnosed in January and out the window late in August I saw the trees begin to turn yellow. Out the same window I had not noticed the white of winter nor the melt of March nor green leaves when they arrived in April. We inhabited not the natural world but the landscape of leukemia. I read a draft of "Without" to Jane, the unpunctuated universe an unchanging relentless blank. From her bed Jane said, "You've got it, Perkins. You've got it!" A year later I revised the poem, put it into the past tense, and used it as the title for my book of poems about Jane's death.

In the weeks after her funeral I drove four times a day to her grave. I read only novels that exercised rage and misery: *Blood Meridian* not *The Ambassadors*. I took pleasure only in disaster: the Oklahoma City bombing, an airplane crash in New York with everyone killed. My days were misery except for an hour in the morning when I revised the wailing and whining I had drafted beside her hospital bed. I had begun "The Porcelain Couple" and "The Ship Pounding" while she lived, and now I revised them together with "Without." Today I understand that these poems of Jane's death already be-

gan to bring my language back to life. I remember the first poem I started after the funeral. One morning I looked out the window at her garden. Her peonies, the basketball-sized white triumphs of her garden, stood tall and still unopened late in May, with weeds starting from black earth around them. I began a poem that by autumn became "Weeds and Peonies."

> *Your peonies burst out, white as snow squalls,*
> *with red flecks at their shaggy centers*
> *in your border of prodigies by the porch.*
> *I carry one magnanimous blossom indoors*
> *and float it in a glass bowl, as you used to do.*
>
> *Ordinary pleasures, contentment recollected,*
> *blow like snow into the abandoned garden,*
> *overcoming the daisies. Your blue coat*
> *vanishes down Pond Road into imagined snowflakes*
> *with Gus at your side, his great tail swinging,*
>
> *but you will not reappear, tired and satisfied,*
> *and grief's repeated particles suffuse the air—*
> *like the dog yipping through the entire night,*
> *or the cat stretching awake, then curling*
> *as if to dream of her mother's milky nipples.*
>
> *A raccoon dislodged a geranium from its pot.*
> *Flowers, roots, and dirt lay upended*

in the back garden where lilies begin
their daily excursions above stone walls
in the season of old roses. I pace beside weeds

and snowy peonies, staring at Mount Kearsarge
where you climbed wearing purple hiking boots.
"Hurry back. Be careful, climbing down."
Your peonies lean their vast heads westward
as if they might topple. Some topple.

It was Jane's "prodigies," it was Jane's "magnanimous" blossoms, it was Jane who noted the "repeated particles" of snow. After her death I was able again to assume a diction as potent as Jane's. I finished "Without" and "The Porcelain Couple" and "The Ship Pounding." I wrote "Letter with No Address" in our common language, and continued my posthumous one-way correspondence through "Letter after a Year." After I published *Without* I continued to write Jane poems in *The Painted Bed*, sometimes returning to metrical forms. In the months and years after her death Jane's voice and mine rose as one, spiraling together images and diphthongs of the dead who were once the living, our necropoetics of grief and love in the unforgivable absence of flesh.

IV

A CARNIVAL OF
LOSSES

MILLTOWNS

EVERY FOUR YEARS DURING THE NEW HAMPSHIRE primary, television networks conduct interviews in front of Manchester's old mills. Long brick buildings extend on the eastern shore of the Merrimack River, where for a century farmers' daughters turned cotton into yard goods that clothed the United States. Generations worked at adjacent machines, wool instead of cotton from 1861 to '65, until after Reconstruction southern mills replaced New Hampshire's. Manchester and Franklin became neglected milltowns, as did Newport and Claremont and dozens of other places. Old storefronts emptied on poverty's main streets as jobless millworkers went hungry. Their children applied for food stamps. Their great-grandchildren are routinely diagnosed with ADHD in return for disability checks.

Every old town in New Hampshire grew up beside water. Some mills manufactured one farm implement, in towns so small that they escaped impoverishment when the mill closed. I live near Elkins, a village on a small river that flows out of Pleasant Lake. It was called Scytheville before Dr. Elkins died. Its tiny dam channeled water to grind and sharpen scythes. How many people worked at the mill? Not many, but for the few millworkers and their families the village before automobiles required a grocery store, a post office, a butcher, a fishmonger, and Dr. Elkins. The mill created a tiny town.

Sometimes there were one-man mills. My great-grandfather John Wells was a blacksmith. Like everyone in the coun-

tryside — lawyer, preacher, milkfarmer, carpenter, doctor — he had to be a subsistence farmer as well. He had one horse, one cow, a big garden for canning, chickens and sheep and pigs — and shoed his neighbors' horses for his taxes, for his salt and pepper, for strips of flypaper to hang over the range. Once a year he became a miller. Behind his blacksmith shop a stream trickled all summer, but in spring's melt the Blackwater River briefly roared, to power a saw by which he cut wood and built a buggy every April.

Wherever there's a town, there's water. Five miles away from me is the village of Andover, site of a prep school called Proctor Academy, across the road from the Proctor graveyard where Jane Kenyon lies. Half a mile west of Main Street, if you know where to look, a barely visible stream flows beside barely visible ruins. Bricks and crumbled cement mark the site of Proctor's Mill, where workers made hames, the wooden frames that underlie a horsecollar's leather. Every spring, my grandfather remembered, farmers came to the mill with cart-loads of ash, the best wood for making hames. My grandfather worked there a month when he was young, and quit when the sawdust made him sneeze all night. Millworkers labored twelve hours a day, Monday to Friday, six hours on Saturday. Five years earlier, when the Proctors shortened the hours of labor from six full days to five and a half, old-timers snorted that it wasn't a week's wuk.

MY CONNECTICUT GRANDFATHER

H.F. CUT QUITE A FIGURE WHEN HE WAS IN HIS TWEN-
ties. He grew a mustache, labored with his father all day, and
courted all night. He visited a girlfriend with his horse and
carriage, and conducted his *amours* in the wobbly front seat.
After he terminated one romance, he picked up his new date
and one thing led to another. His mare kept moseying along
—the horse knows the way—and came to a stop at the old
girlfriend's house.

MUDFISH PISSING

JILL HOFFMAN, A PAINTER, POET, AND FICTION WRITER, edits a thick and handsome literary magazine called *Mudfish*. In the autumn of 2016 she sent my agent Wendy Strothman a letter asking if Wendy could get me to judge the poems in a forthcoming issue. For #19, Edward Hirsch had been the judge, and #20 would be my turn. She was a fan of mine, she told Wendy, and she had given a speech at my sixtieth birthday party. "I wrote about it," Jill Hoffman said, "in a novel (*Stoned*) and meant to send the scene to him many years later but I never did."

Late in my eighties, I have so far avoided dementia. I have problems with memory, sure, but it's short-term memory. Jill Hoffman did not give a speech at my sixtieth birthday party. I vividly recollect my sixtieth. Jane threw me a bash on the seldom-used second floor of our favorite restaurant, Piero Canuto's La Meridiana. My friends gathered from all over and had a choice of sirloin strip or rack of lamb. Jeff White recorded the whole party on camera. My granddaughter Allison attended, six weeks old, and swung back and forth in a mechanical device that kept her asleep. (Her first cousin Emily, four days older, was detained in New York with a sore throat.) For Jane and me, it would turn out to be our last such celebration. Not long after, a surgeon extracted half of my cancerous liver. When I recovered, Jane died of leukemia. Yup, I remembered my sixtieth birthday party.

And who's Jill Hoffman? When she answered my bewil-

derment, Ms. Hoffman told me that several of her decades had vanished — something to do with her being *Stoned*? She thought maybe it was Richard Wilbur's sixtieth birthday at which she gave a speech. (At ninety-six my old friend Dick didn't remember.) I told Ms. Hoffman that anyway I was too old to judge a contest. When I told her my age she understood, and she remembered something else. In *Mudfish* #17 she had published a poem by a guy named Steve Benson.

PISSING BESIDE DONALD HALL

It was before a reading at Drake
downstairs in the Men's Room
not long after his young wife,
the praised great poet Jane Kenyon,
died with depression and leukemia
slowly we stood there pissing
side by side at shiny urinals
if you're a man you know how
intimately private yet exposed
this public pissing is and I was
tempted to tell him how much I love
his poetry the Ox Cart Man still
one of my favorites and how sorry
I was about his wife dying bravely
talented so young and would he mind
signing his newest book of poems
I'd tucked wing-like under my elbow

while I stood there quietly aiming
my own pale yellow stream into
the universal porcelain bowl
but for once I told my ego NO
just let The Famous American Poet
pee in peace shaking off his golden
drops until we zipped up about the same
time and washed our hands before
a wide mirror where we nodded at
each other's reserved reflections
drying our hands on ripped paper
and then he led the way upstairs
to spontaneous applause where
I returned to my seat proud of him
and my secret self content for once
to permit what's loved to peacefully go.

I didn't know Steve Benson. I didn't remember a man pissing beside me at a urinal. I didn't remember reading my poems at Drake University in Des Moines, Iowa. On the Internet my assistant Kendel found a Language poet with the same name, but Language poems don't make a noise when read aloud and this one did — nice line breaks — and I liked the part about the Famous American Poet. It had to be another Steve Benson. Jill Hoffman gave me *Mudfish* Steve Benson's email address, and now he and I write back and forth, our urinal companionship gone electronic and verbal. We talk about having a beer sometime, in order to take another piss together.

Steve didn't remember when I read at Drake, and I never

remember the dates of poetry readings. Steve's poem said it was after Jane died in 1995. Then Kendel discovered a list of Drake's 2017 English professors. Professor Jody Swilky was listed as director of the writing workshop at Drake, so I asked her about my reading. She "conducted some research," she answered, "and discovered that in 1991 you participated . . . in the Des Moines National Poetry Festival." For Steve Benson, as for most of us, everything is longer ago than we think it was.

Anyway, Jill Hoffman—editor, poet, novelist, painter— and I have become epistolary buddies too. I have never met either of them, nor most of the people I correspond with, which is how my archive has accumulated so many acres of letters. Promiscuous in legible acquaintance, I praise solitude in essays and dictate fifteen letters a day. Jill Hoffman asked me to contribute to *Mudfish* and wished to paint my portrait. I sent her photographs of Jane and me. She emailed me a digital photograph of my portrait, in which one of my eyes is lower than the other, her friend Jack tells her, and another of Jane in which the mouth is not quite right. (John Singer Sargent said that in portraits the mouth is never quite right.) A future issue of *Mudfish* will run Jill's painting of me on the front cover and Jane's portrait on the back. In pages between the covers Jill will print this bulletin, and also my meditation on "Fucking."

RICHARD AT OXFORD

AT OXFORD EARLY IN THE 1950S, I KNEW AN AMERI-
can who wanted to be a writer. Nobody liked him. Between
Yale College and Oxford he talked himself into a Communist
Youth International conference in Paris, and in an article for
Look revealed its Stalinist ideology. What a surprise. After Ox-
ford he wrote a popular book about how to get rich. He knew
nothing about getting rich, but he knew how to write a book
about getting rich. Then he died. It was a while ago.

My wife and I had a flat about two miles from the town cen-
ter, and Richard knocked on our door every Sunday midday.
Always we asked him to stay for dinner, until at last we'd had
enough. On a dreary November Sunday he arrived and I said
that we wouldn't ask him to stay for dinner today — because
I had a headache, or because we didn't have enough food, or
because of *anything*. Richard stared out our window at rainy
Banbury Road and said, "It's so unpopular outside."

FROM ANDREW ALL THE WAY TO LUCY

USUALLY IT'S SOMEONE ELSE WHO GIVES ME AN IDEA for a children's book. It seems I've written a dozen. I wrote my first when my four-year-old son Andrew commissioned it. In Ann Arbor we occupied an old farmhouse in a crowded suburban neighborhood. In the morning Andrew with his shock of red hair opened the door of our white house to fetch the newspaper. Because he was also wearing blue Dr. Denton's, our neighbors said that he looked like the Fourth of July. Inside our house, at the end of our living room, a big window faced the street. At its bottom was a recessed shelf with flowerpots resting on gravel, where my wife grew flowers all year. One afternoon Andrew told me he had a great idea, but it was scary. "I'm going to the Lion Store," he told me, "to buy a lion seed and grow a lion in the window!"

It took two years for *Andrew the Lion Farmer* to be published. Andrew was proud that he had given me the idea for a book. (At sixty-two he's still proud.) Back then, we never visited the Lion Store, but I went to pad and paper, and in a week or two I had a story. I sent it to my agent, who tried it here and there, and finally found an enthusiastic small publisher called Franklin Watts. They liked Andrew's plot and hired the illustrator Jane Miller to draw the redhead buying a seed at a Lyon's establishment. Andrew's imaginary pet blossomed to play with him every morning before the grown-ups woke. In September the lion began to feel sleepy. "I think I'm going to

seed." Was Andrew's lion perennial or annual? If he was annual, I might try a sequel.

The book was wordy. My editor asked me to cut it. I cut it here, I cut it there, but I never cut it enough. My editor gave up—and when I look at it now, it's the wordiest picture book in history. Jane Miller drew a wonderful sloppy orange lion with a sloppy orange-headed Andrew, but no one bought it. No one bought it in England either when somebody printed it with different illustrations. The new pictures were terrible —Andrew resembled a kewpie doll—but still it didn't sell.

For quite a while the lion farmer remained my only children's book. The next one might as well never have existed. In Boston an old student of mine worked for a small publisher. She wrote me to commission a children's book of riddles. Because our survival in New Hampshire depended on my freelancing, I accepted every suggestion a publisher made. I made up riddles, I stole riddles, I invented a protagonist named Riddle Rat. A *New Yorker* cartoonist drew pictures and no one read it. Then Paul Fenton told me about the farmer who walked beside his ox cart all the way to Portsmouth. By then, many years after Andrew's lion, I knew enough not to make the book wordy.

A year after *Ox-Cart Man*'s indecent success, I went peculiar with another story. One of the joys of my childhood was my New Hampshire cousin Freeman Morrison, the one with George Washington the ox. No one else in the 1930s and '40s wore a beard. Freeman shaved it every summer but grew it back when the leaves turned. Once a year Freeman washed his clothes and himself. He walked fully clothed into Eagle Pond

with a bar of soap, applying it to his body and his overalls at the same time. Otherwise he lived alone with his pet ox in a shack halfway up Ragged Mountain. I wrote a children's book about him, a story called *The Man Who Lived Alone*, for kids who knew nothing about solitary old bachelors living in huts with pet oxen. No publisher would touch it except for David Godine, who designs and prints good books that nobody else will take. David keeps them in print. He published *The Man Who Lived Alone* thirty-five years ago with black-and-white expressionist woodcuts by Mary Azarian and sends me an infinitesimal royalty from time to time.

Next I made up a story about a kid who missed his father, who was drafted into the army in 1942. His father enraptured him by coming home on leave. That was my plot for *The Farm Summer 1942*. My literary agent wanted to sell two children's books at once. I gave him another manuscript together with *Farm Summer*. For years I had taken notes on a cat book, *I Am the Cat*, and then Jane and I adopted Gus the dog. It wasn't long before I finished *I Am the Dog I Am the Cat*. Two monologists faced each other page after page. One of my characters claimed that the people who fed him were the most adorable people in the world, even though he ate the cat's doodoo, but his housemate didn't give a fuck about anything except mushy canned fish. The illustrator for both books was Barry Moser, who in his long life has illustrated everything. (I once posed as Ecclesiastes for his Bible.) My only complaint about Barry: I wrote about *my* dog and cat; he painted *his*.

So I had two books to offer around. Again and again publishers offered to buy *The Farm Summer* but didn't want the dia-

logue of household pets. My agent was relentless. The forty-third publisher he approached, or maybe the fourth, agreed to do the dog-cat in order to print *1942*. As you have already suspected, no one ever read *The Farm Summer 1942* — I keep a virginal pile upstairs — and *I Am the Dog I Am the Cat* continues to sell today.

Three or four others were published that nobody read and nobody needs to read about, but another two derived from my mother's memories. Lucy died at ninety in an old people's place in our market town. She was born in 1903 in the farmhouse that Jane and I took over, and at twenty-five she married my Connecticut father, their wedding in the sitting room where I write these words. Although she emigrated from New Hampshire to my father's suburban Hamden in Connecticut, she remained attached to the farm and took me here on visits when I was little. Often she told me girlhood memories, which I turned into two children's books. *Lucy's Christmas* came from her tales of old children's Christmas parties, in the white clapboard church that Jane and I went to. People actually read the book, at least at Christmas. I followed it with *Lucy's Summer*. To my old mother in her bed among the dying, I brought proofs, galleys, and finished books. I never saw her more excited. She was making books!

They were published after Lucy died and sold well. *Lucy's Summer* trailed behind her *Christmas*. If I had had the brains, I could have switched her birthday from its real April to an invented July or August and called it *Lucy's Birthday*, a title that would have sold the book all year. I did think of a sequel. In real life, Lucy and her sister Caroline didn't notice, at

seven and six, that their mother's waist gradually extended. They visited an old lady cousin for three days, and when they came home they found their baby sister Nan. I didn't get to write *Lucy's Baby* because the picture book industry slid into a depression and my Lucy books went out of print. David Godine resurrected them much later, and twenty-five years after Lucy died, her *Christmas* erupts in bookstores every December while she edges toward 120.

THE WORLD OF MEATS

JANE AND I DROVE TO MY MOTHER'S HOUSE IN CON-necticut once a month. We cruised over New Hampshire's Route 11 past George's Mills, past Sunapee, through the old milltown of Newport, where we stopped at a massive butcher's establishment rising on the right side of the road—not a butcher's, really, but a butchers'. Squads of burly men with cleavers in their hands wore white aprons stained with blood. This business wore its name on its roof in stout capital letters: THE WORLD OF MEATS.

We stopped there because my mother Lucy loved tripe. Growing up on the family farm, my mother and her family ate everything they raised, not only cows but the linings of their stomachs. Once I ate a bite, which was enough for me but not for Lucy. She simmered a frying pan of tripe in her Connecticut kitchen and ate it with gusto and vinegar. None of the supermarkets near us in New Hampshire stocked tripe, and no one in Connecticut had ever heard of it. Thus, on the way to Connecticut for a visit, we stopped at The World of Meats, where the gleaming gristle pocked with squares lay out on trays. Otherwise the whole establishment was nothing but blood dripping on aprons, on the tiled floor behind the counter, toward a drain in the sloping floor, or on the hands of the butcher who worked the cash register.

My cousin Freeman Morrison lived alone in a shack, always called a camp, on Ragged Mountain. I keep telling stories about Freeman. When I think of The World of Meats, I think

of him. In middle age, 1920 or so, he had another toothache. He had pulled out most of his teeth with pliers, but the remainder were rotten and his pliers slipped on the stumps. He heard tell of a man in Franklin called a dentist, and somebody gave him a Model T ride to town. After half an hour, toothless Freeman walked from the office holding a towel over his mouth, which didn't keep blood from drizzling over his beard and his shirt as he talked all the way back to his camp. Freeman himself was another World of Meats.

THE TRIPLE THINKER

AT HARVARD, THE SOCIETY OF FELLOWS DID A FOR-
mal dinner every Monday night. Sometimes the senior fel-
lows brought guests to entertain us juniors. One night I
ate dinner with Vladimir Nabokov. T. S. Eliot came once a
year. Edmund Wilson came twice, but I never happened to
talk with him at one of our dinners. Then Wilson invited
the junior fellows to a party at an apartment he was rent-
ing in Cambridge. I hadn't especially enjoyed his 1931 es-
say "Is Verse a Dying Technique?" but I grew up reading
To the Finland Station and admired his frequent *New Yorker*
pieces. At his house I chatted with other guests as Wilson
moved among us. When he came to me he asked, "What do
you do?" He looked snappish. (I too get irritated when peo-
ple fawn over me after a poetry reading. Maybe I called him
"sir.") I didn't want to say that I was trying to resuscitate his
moribund art. I told him that I looked into the prosody of
modernist poetry.

"Never use that disgusting word!" he bellowed, his face
turning red. "It's disgusting! It's revolting! It's obscene!"

I knew which word he meant. At that moment my old col-
lege tutor Harry Levin approached, who at twenty-five wrote
his book about James Joyce and was now an aging and agree-
able professor. He heard Wilson say, "It's obscene! It's obscene!
It's obscene!"

"He means the word 'modernist,'" I mumbled.

"Why Edmund," said my old tutor, "I believe I've used that expression. Why Edmund, I believe you've used it yourself!"

It was too much for Wilson. His face turned a deeper crimson. He repeated "Obscene!" and fell full length to the floor.

THE WORST THING

WHEN I FIRST ARRIVED AT HARVARD IN 1947, I LIVED
in a freshman dorm beside two African American roommates,
called Negroes at the time. There were eleven Negroes in the
class of 1951. I took to Matthew Botney, who intrigued me be-
cause in addition to his skin color he was a member of the
Communist Party. In 1947 it was comfortable enough to be a
communist at Harvard. A tall commie from Beacon Hill stood
outside Harvard Yard at lunchtime, calling in a Groton ac-
cent, "Get your *Daily Worker*! Get your *Daily Worker* here!"
Myself, I never joined the party, but I had thoughts about it.
When Matthew returned for sophomore year, he had left the
party. He said he preferred stretching out on a beach listening
to a portable radio. I liked him anyway. He became my room-
mate in Eliot House, where we lived with two other students
on the fifth floor, with a common bath and living room, a big
bedroom for two, single rooms for Matthew and me. At first
all four of us enjoyed one another, but in the spring of our ju-
nior year Matthew began to separate himself from his room-
mates. He rented cheap, bright, non-institutional furniture for
his single room. He started staying out all night. We teased
him about his girlfriend.

Harvard when we matriculated was not only politically tol-
erant but otherwise loose and easygoing. Three years later, the
country and the college altered as the House Un-American
Activities Committee took over. Even homosexuality had been

open and commonplace from 1947 to 1949. John Ashbery and Frank O'Hara were our best poets. The university officially proscribed homosexuality, but paid no attention when people appeared to be gay. Guys walked around holding hands. By 1950 we were aware of HUAC and general tolerance receded. One day Matthew vanished entirely and his furniture was repossessed. It took a month before we discovered that Matthew had been expelled for being gay, his frequent overnight companion an elderly Brahmin on Brattle Street. The white-haired lover was not the only one. Eliot House had an elegant library with many nooks and crannies, books shelved in cubicles for quiet study. The university hired Irish women from Boston to clean our dorm rooms, women we cleverly called biddies. One day a biddy dusting the library saw a black man kissing a white man. There were many Caucasians in Eliot House; there was one Negro. Harvard expelled Matthew, doubtless to forestall a *Boston Herald* story. I never saw him again. I spoke just now of Harvard's "general tolerance." Seventy years later it is remarkable to understand that no one in Harvard's administration would have considered anything but expulsion.

TWO YEARS later, I was at Oxford on a fellowship and lived in Christ Church College. One day I received a note from the city police, asking me to drop by. I was more curious than alarmed. My only crime at Oxford had been to climb into college after hours. At the police station a constable directed me to a room where I found a middle-aged American smoking a cigarette.

He wore a generic brown suit and an anonymous tie, and told me he was from the Federal Bureau of Investigation. He said that Matthew Botney had applied for a job in a defense plant. "Was he ever a communist?"

That's when I did the worst thing. "Yes," I said.

FIVE OF THEM

MY MOTHER LUCY KNEW ALL HER GREAT-GRAND-
children, because in the old days people married young. My
mother and father married at twenty-four, and their only child
was born a year later. Myself, I married at twenty-three, and
my son Andrew came along in two years. He sired three chil-
dren and my daughter bore two. My mother's five great-grand-
children attended her ninetieth birthday party.

Jane and I drove once a month from New Hampshire to
Lucy in Connecticut, throughout her eighties, and arrived as
scheduled on April 22, 1993. We had arranged in secret for her
grandchildren to bring her great-grandchildren for a visit the
next day, a surprise on her birthday. Andrew and his wife Nat-
alie arrived first with two daughters and a son, closely followed
by Philippa with two daughters. I preserve the gathering in
a huge photograph stuck to my refrigerator. Jane posed us
squeezed onto a sofa around my mother in her perpetual caf-
tan, babies and children and grown-ups, everyone smiling, my
mouth wide-wide open. We had brought a birthday cake. Af-
ter a joyous hour, I noticed that Lucy was exhausted, sagging
into her seldom-used sofa. At my urging the visitors packed up
and departed while I steered the ninety-year-old to take a nap
on the reclining mechanical chair—where she lived out the
late track of her life, where she wrote many letters, where she
listened to the radio Red Sox, where she read the same Agatha
Christies over and over.

· · ·

MY DAUGHTER Philippa, younger than my son, was first of my children to marry, she and Jerry in 1984. Andrew and Natalie got together three years afterward and bore my first grandchild, Emily, nine months later. It was an extraordinary summer, as Philippa's daughter Allison emerged from a New Hampshire cesarean section only four days after Emily in New York. Two years later, Manhattan with a baby was too much for Andrew and Natalie, so he allowed a headhunter to recruit him for a Boston firm. They moved north with Emily not long before her sister Ariana arrived in 1990, and then came Peter in 1992, just after Philippa's Abigail. Philippa and Jerry with the girls lived only forty minutes away from Jane and me, and frequently dropped in. Five Halls from Massachusetts regularly drove up to visit.

Three things in particular engaged the young visitors. I kept a box in my study and spread its contents on the living room floor when the grandchildren arrived. Bizarre plastic constructions embodied or parodied my writerly profession in an outlandish assemblage of ballpoint pens: a football player pen, a yellow plastic banana with a blue nib sticking out, a fire truck pen, a luxurious Brigitte Bardot Bic, cat pens and dog pens, a Holstein pen, and one that when persuaded urged "Go! Go! Go!"

One Christmas gift brought another order of joy. Jane's brother and sister-in-law sent annual boxes from Michigan, and their presents tended to be imaginative or witty. A large wooden crate arrived, three feet long, which Jane and I opened to discover a gumball machine, replete with gumballs and a

slot that accepted pennies, with a chute that granted gumballs in return for pennies. For at least a decade, five grandchildren opened car doors and zapped into the house bearing coins outstretched.

And when they had grown a bit bigger there was a third attraction. Late in my eighties I live entirely on one floor of my house, but above me are a second floor and a third, where you can find a spinning wheel for wool and another that twisted flax into linen. We call our major junkroom the Back Chamber —dark, cluttered, assembling everything one family had used and broken since 1865. When Emily and Ariana and Peter visited us, or Allison and Abigail, after equipping themselves with gumballs they scrambled upstairs to investigate the Back Chamber. There were chests like pirates' chests crammed with the nightshirts and underwear of great-great-grandparents born in the first half of the nineteenth century. There were broken china heads from the dolls that my mother and her sisters cherished, one for each girl as her annual Christmas present. There were ancient colloquial chairs painted farmhouse green, each with a broken strut. There were two crumbling Singer sewing machines with foot pedals that once powered needles into Sears-boughten cloth. There were huge slick catalogs from Montgomery Ward and twelve beds broken down and stacked against the wall. There were piles of *Farmer's Journal*s. There were even toothpick sculptures executed by young Andrew and Philippa, my son's towering and precarious beside my daughter's scrupulous and symmetrical.

Five grandchildren would linger upstairs, Columbuses who

cherished a dusty and broken old world—and when they drifted downstairs they were tired, they wanted one more gumball, they were ready to nap in the back seat driving home.

AS THE grandchildren aged, from grammar school into junior high, every year they were taller and spoke in longer sentences, even in paragraphs. The attraction of the gumball machine endured, and it awaits the great-grandchildren. In the meantime, there was a private school on Commonwealth Avenue in Boston, there were demanding public schools in Bow, New Hampshire—and then the University of Chicago for Emily, Vassar for Allison, Bryn Mawr for Ariana, Carleton for Peter, and George Washington for Abigail. After decades of family Thanksgivings and Christmases, five children grew into adults. Emily crossed town to medical school at Northwestern, and Dr. Hall does a residence in Wisconsin. Allison becomes a business consultant headhunted by a major corporation. Ariana finishes a PhD in chemistry at the University of Michigan. Abigail works in Manhattan advertising and flies to Los Angeles for a photo shoot. Peter evaluates *objets d'art* at a New York auction house.

As a grandfather approaches his ninetieth birthday, he remembers his mother's in 1993. Although he lacks great-grandchildren, he chugs on, he chugs on, he chugs on, understanding that eventually each locomotive reaches its roundhouse. My mother was ready to get off the train when it stopped one month shy of her ninety-first birthday.

THE BOYS MARCH HOME

MY NEW HAMPSHIRE GRANDMOTHER'S FATHER, BEN
Keneston (born 1826), was too old for the war, but my grandfa-
ther's father wasn't. John Wells was nineteen in 1862 when he
enlisted for nine months in the Union army. Although he was
a Copperhead, devoted to states' rights, he fought the rebels
to belong to his New Hampshire generation. He died in 1927,
the year before I was born. One of my great-grandfathers em-
igrated from Germany to Connecticut (after Appomattox) to
avoid conscription into the Prussian army. Not the other: Char-
lie Hall was helping to dig the New Haven reservoir when the
Confederates fired on Fort Sumter. At lunch one day he left
his job to walk down to the green and enlist for three months.
After three months he came home to stay. Late in the war he
was drafted—I keep the draft notice in a foldout desk up-
stairs—and although he made only a workingman's wages,
he borrowed the cash to hire a substitute. Later he made sure
that everyone knew he was a patriot. Every Fourth of July he
marched in New Haven's parade, leading Charlie Hall's Fife
and Drum Marching Band.

Ben Keneston's youngest child was my grandmother Kate
(born 1878). Her elder brother, my uncle Luther (born 1856),
sat on the porch with me when he was eighty-six during World
War II. He remembered being nine in 1865 and watching the
boys march home.

DOWN CELLAR

UNDER THE KITCHEN AND LIVING ROOM IS THE ROOT cellar, dark and damp and crowded with engines of the past. A row of barrels stands against one wall, where apple juice became cider became hard cider became vinegar. My grandfather was teetotal. When his father-in-law took friends to the cellar midwinter—atop one barrel was a metal cup—my grandfather walked back and forth upstairs, face turning red. The final product, a cruet of vinegar, took its place on the dining room table and no one suffered from scurvy.

Down cellar, you can still find jugs that held molasses. There are wide-topped empty crocks where my grandmother Kate stored pullets' eggs by the dozen. She filled the crocks with water glass to keep the eggs from spoiling. You did not fry these eggs for breakfast, but you could cook with them all winter. On rows of wooden shelves—the shelves are still there—my grandmother lined up a thousand Ball jars of canned vegetables—peas, pole beans, string beans, corn niblets, beets, lima beans, Brussels sprouts—and tumblers of jellies and jams. I remember in hot summer how the wood-fired Glenwood range boiled vegetables and my grandmother filled the jars, her face as red as the beets she canned.

When Jane and I moved in, we inventoried the root cellar, finding a few pallid pints of tomatoes. The vinegar barrels were empty. The only life in the cellar was a skunk. My daughter Philippa had come east to a Massachusetts prep school, and sometimes we drove two hours to pick her up on a Friday af-

ternoon and drove her back on Sunday. While she visited we explored the old house with its things from 1865 on. It would have been unseemly to throw anything away. One Sunday morning with Philippa we found something in the root cellar we hadn't seen before: a jar of maple syrup that my grandfather last made in 1950, three years before he died. We took it upstairs to the kitchen and opened it, scratching out the dried rubber gasket, and I dipped my finger in — twenty-five years ago, sap had dripped from our maples — and it tasted as sweet as if it had just been boiled down. Each of us licked a finger. Jane made pancakes. An hour later the three of us climbed into the Plymouth Six and headed south to Philippa's school. Somebody rumbled, somebody else rumbled, somebody rumbled all the way to Southborough, Massachusetts. We called it Fart Sunday.

REVIEWING MY LIFE

WRITING BOOKS FROM YOUTH TO OLD AGE, YOU LEARN one or two things. In my twenties and thirties I did a lot of reviewing for papers—the *New York Times*, the *Washington Post*, the old *Saturday Review of Literature*, the *Los Angeles Times*, the expiring *New York Herald Tribune*. The *Trib*'s book editor was Irita Van Doren, who asked me to review Marya Zaturenska, wife of Horace Gregory—two more famous poets you've never heard of. The *Trib* wanted a hundred words and would pay twenty-five bucks. I wrote a disdainful review, and the editor replied that, actually, Marya was a good friend and they wouldn't be able to print my paragraph. Was there anyone else I would like to write about? I praised W. D. Snodgrass's *Heart's Needle* instead of trashing Marya Zaturenska. It took me a year to admit to myself the corruption I'd been party to.

AN OLD HERMIT NAMED GARRISON

SATURDAY NIGHTS JANE AND I USED TO LISTEN TO Garrison Keillor doing *A Prairie Home Companion*. With pleasure we read Keillor's stories in *The New Yorker*. We heard him speak a daily poem on his public broadcast *Writer's Almanac*. We did not know him. When Jane was diagnosed with leukemia, she received from his Minnesota office a package containing four cassettes of his monologues. How did Keillor know that Jane was sick? He has always known everything about poets.

He's also stubborn. Once I was doing a textbook and asked his permission to reprint an essay. He refused because my publisher belonged to a conglomerate, one branch of which had published an unauthorized book about him. I prettypleased him, addressing him as "Garrison." He wrote back briefly repeating his decision and addressing me as "Mr. Hall." Later a friend of mine wrote Keillor offering him a prestigious American poetry award, explaining that the honor was for his service to the art. In a handwritten letter he expressed his gratitude, included an inscribed copy of his latest book, and refused the honor. He pointed out that he wasn't a poet.

These days the Poetry Foundation, the Academy of American Poets, and *Poetry Daily* display a different poem online every twenty-four hours. Whatever the appetite for a daily poem publicly displayed, clearly it is satisfied. Keillor's *Writer's Almanac* repeats itself digitally as well as audibly — but before the digital universe, for decades, *only* his radio *Almanac*

delivered a poem coast to coast, 365 days a year. No one has ever promoted poetry so widely as Garrison Keillor.

Keillor also promoted poetry by drafting poets as guests for *Prairie Home Companion*, until he retired in 2016. Billy Collins performed seven times that I know of. My total was three. My first appearance celebrated the 100th birthday of Keillor's St. Paul homeboy F. Scott Fitzgerald, in the show's St. Paul theater. I came equipped without a script but with a schedule — when to arrive, when to eat, when to rehearse — and backstage I found an improvised cafeteria where I assembled my supper.

I awaited rehearsal. There was no rehearsal. No one told me what was I supposed to do. Then I discovered: every Saturday night Keillor appeared to make up the show as he went along. For actors performing skits, and for the soundman's genius, during the week Keillor must have given a hint. Daily, when he drove from his house to his workplace, he daydreamed his monologues. When he performed them, he watched minutes elapse on a clock, adding or subtracting to fit the time remaining. For his Fitzgerald birthday party he invited a bunch of writers, mostly novelists, and sat us in the theater's front row, before a ramp that led up to the stage. I heard Keillor speak about Fitzgerald's great novel, then announce, "I'm casting Donald Hall as Jay Gatsby."

It was the first I had heard of it. He handed me a script, gave me directions out loud, and everything turned out all right. With Garrison Keillor, everything always turns out all right. On my second visit, I was his main guest, and before the show he asked me to come watch him shave. Yes, he shaves for his

radio show. As he plied a straight razor he told me that during the program we two should say limericks to each other. Did I know any? I said I knew one that wouldn't do on public radio:

> There was an old hermit named Dave
> Who kept a dead whore in his cave.
> He said, "I'll admit
> I'm a bit of a shit,
> But think of the money I save."

He said it was fine and dictated another for me to say after I had finished with Dave. We would perform our limericks after a musical interlude, first me and then him. During the show, as the band slowed down just before our limericks, Keillor changed his mind. "Let's go back and forth," he told me. "We'll one-up each other." It came out all right.

The last time I did it, the show was at Tanglewood in 2008, the year I turned eighty, and Linda drove us to a motel in Lenox. Midafternoon we climbed onto a rattling bus to take us to the Tanglewood auditorium. It was eight times the size of the St. Paul theater, and every seat would be occupied by a western Massachusetts summer bottom. Another two thousand fans sat on the grass outside, listening to the show through speakers. Half an hour before things got started, Keillor approached Linda and me. Linda had never observed his actual face. It bulges here, it bulges there, possibly assembled from spare parts. Any sense of menace vanishes as soon as he speaks. He caresses whom he addresses. He spoke of books I had published since our last meeting, then warmed up the au-

dience for twenty minutes. He didn't need to warm anybody up, but he liked warming people up.

Half an hour into the show, staffers lugged me across the stage, set me on a chair, and Keillor kneeled down beside me to chat. I said my poems, staff carried me back to Linda, actors did a skit. Then Inga Swearingen, a pretty young singer, did three songs. A cappella, she sang "Summer Kitchen," a twelve-line poem of mine about Jane. She made up the tune and I loved every note. After the intermission I said more poems. Garrison asked me if I kept livestock at the farm. I told him no and then corrected myself. I had a cat. Garrison noted that it was difficult to milk a cat, and my handlers carried me back to Linda. When the radio show stopped at seven, Garrison didn't stop. He walked around the auditorium saying goodbye. The inside crowd straggled out, and the outside crowd filed in. He had talked for two and a half hours, from warm-up to show to first farewell, and now he extended himself another thirty minutes, singing variations on "I'm tired and I want to go home." Then everybody went home.

FUCKING

IF YOU PICK UP SOMEBODY IN A BAR OR AT A PARTY OR on the street, it's exciting to take her/him home and rip his/her clothes off. If you fuck a stranger, or your best friend's husband or wife, or both of them, it's immoral, treacherous, forbidden, nasty, and therefore thrilling. Sex is getting away with something. Or it's numbers. I asked a dear old friend how many women there had been. We were friends from college, and I knew that his Asperger's would give me a figure. "Including whores? Six hundred and eighty-seven."

Really, sex is best-best, not because of secrecy or shock or crime or numbers. Indeed, the best-best fucking requires *no* adventure, *no* variety, *no* betrayal, *no* vanity. It is the invariable ecstasy of habitual double orgasm. A couple who've been together for years, as familiar as laundry soap, don't think about *love* or *wickedness* or *how many does this make?* but about rubbing, licking, sticking something into something, or being stuck with something—until the KA-BOOM and the magnificent respondent KA-BOOM. Afterward, happily the fuckers chat about Tuesday and the grandkids and oatmeal and contract bridge.

THE WIDOW'S HOUSE

OFTEN I'VE WRITTEN ABOUT BECOMING INVISIBLE IN
old age. Did I say that when I was young I was as eyeless as any-
one? When I was twenty-four, on a California fellowship that
paid $2,000 a year, my wife and I rented a nondescript apart-
ment in a widow's house — $35 a month for a tiny porch with
natural light outside a sitting room with no windows next to a
dim bedroom. We shared a bathroom and a kitchen with a di-
vorced mother and her son, who occupied two rooms upstairs.
Although we tried to use the kitchen at different times, inevi-
tably we bumped into each other. I made sure we didn't bump
into the widow. Rarely she knocked on our door and poked
her head into our hole. Maybe her granddaughter was visit-
ing and she needed me to move my car. She smiled, bending
toward me, teetering in decrepitude, her face misshapen and
her hair thin and scraggly. She gazed at me, smiling and soft,
as if with entreaty. We did not chat. I call her invisible because
I wouldn't look at her. We lived in her house for a year and I
wrote her twelve checks and I do not remember her name.

WAR CARDS

WALKING HOME FROM FOURTH OR FIFTH GRADE, MY classmates and I stopped at a drugstore to spend a nickel for a wad of gum. It came in a pink slice, dented so that you could break it into five oblongs, and it completed itself with a baseball card or a G-man card (FBI agents shooting Dillinger at a Chicago movie theater) or by the sixth grade a war card. The same flavorless gum by this time featured mass slaughter. A Japanese warplane bombed a Chinese bus and Chinese corpses flew through the air. When the Spanish Civil War started, a war card showed us a firing squad at work. At eleven or twelve I began to read the *New Haven Register*—General Franco reviewing the troops, Nazi warplanes bombing refugees in a mountain pass—and threw away my war cards.

From December 7, 1941, for three and a half years every American headline of every newspaper was America at war. What would newspapers manage to talk about if peace ever happened?

My father and mother, both born in 1903, had lived through an earlier war. I connected to their old war, attending to my ancient farmhouse, when my carpenter removed worn-out linoleum from the parlor floor and discovered the front page of a newspaper dated July 3, 1916: ALLIES CONTINUE THEIR GREAT DRIVE IN SOMME SECTOR. At the time, my mother Lucy lived here at thirteen. I tack the old front page with its headline on the wall of my workroom.

The first day of September, 1939, I saw Connecticut news-

boys shouting and waving newspapers at intersections. I re-member the Pacific of early 1942 — Japanese soldiers invad-ing the islands, our destroyers sunk, MacArthur escaping from Corregidor on a submarine. I remember Operation Torch, No-vember 1942, when we landed in North Africa to fight Rom-mel, later to invade Europe by way of Sicily. At home near my family dairy, a factory turned out Winchester rifles. Se-nior boys in high school earned 35 cents an hour assembling guns after school. A student from my high school was killed in the third wave at Tarawa. I was sixteen for V-J Day. As a college teacher I watched Vietnam explode in the streets of a college town. I marched on Washington with my son. In 2001 and 2003 our volunteer armies, poverty's mercenaries, invaded Afghanistan and Iraq. This time there were no marches on Washington. Nixon had canceled the draft.

ABSTRACT EXPRESSIONISM

IN 1959 I VISITED THE CEDAR STREET TAVERN IN THE
West Village and drank a beer, hoping to bump into Willem
de Kooning, Larry Rivers, Marisol, Jackson Pollock, Elaine de
Kooning, Alex Katz, Joan Mitchell, Jasper Johns, or Phidias.
No luck. I stood at the bar with a cigarette and a Heineken.
Against the wall behind me stood four or five silent young
men. A man at the bar beside me asked one of them if he'd
like a drink. "I don't play games," the young man said.

BACK IN THE DAY, YOU HAD TO HAVE LATIN IN ORDER to get into college. On top of my four years of Latin I added a year of Greek in prep school and received a classical diploma. It was the only way I could avoid taking science or math. Both my Greek and my Latin have abandoned me, but they have left derivatives behind, by which I understand new words. When I first went to an ophthalmologist — the telephone book had become inscrutable — he examined me, then gravely announced in accents of doom, "You have presbyopia."

"Old eyes," I told him. It was my Exeter Greek. Presbyterians are elders; eyes are often optic.

Nobody studies Greek anymore, but all of us speak Latin every day: ad nauseam, seriatim, ergo, non sequitur, ad hoc, rigor mortis, persona non grata, alibi, carpe diem, ars gratia artis, ad infinitum, magna cum laude, ne plus ultra, quid pro quo, postpartum, mutatis mutandis, ego, ex cathedra, terra incognita, Homo sapiens, ex nihilo, in vitro, casus belli, habeas corpus, in medias res, ex libris, id, errata, postmortem, ave atque vale, in vino veritas, magnum opus, mens sana in corpore sano, passim, sine qua non, ibid., placebo, compos mentis, data, Magna Carta, deus ex machina, vox populi, pax vobiscum, ecce homo, mea culpa, tabula rasa, ex parte, ad hominem, semper fidelis, bona fide, quasi, stet, quorum, paterfamilias, tempus fugit, ipso facto, verso, terra firma, ex post facto, incognito, sub rosa,

Etc.

FRYING PULP

MY DENTAL ADVENTURES IN CHILDHOOD BEGAN WITH a New Haven practitioner who forbade using a toothbrush. Brushing wears off enamel, he explained. Whoever my dentist was, even after I was permitted to clean my teeth, every visit revealed a multitude of cavities, twenty-seven on one occasion. After college I went to Oxford, and dared not entrust my mouth to an English dentist. You needed only regard an English mouth. When I flew from London to Paris at Christmas, I had developed a persistent toothache. I sought a French dentist, and found one who had done his degree at NYU in the nineteenth century. He told me that my tooth required reaming out. He offered options: he could freeze me up and use his modern tools, or he could burn the rot out by sticking a hot wire inside the tooth. The modern procedure would cost more than the old-fashioned one. I sat in the chair while the dentist heated the wire and showed me the white-hot tip. As it entered my tooth I listened to the sizzling and sniffed the aroma of frying pulp.

Decades later, my periodontist installed four implants behind the partial bridge on my lower jaw, two to a side. He drilled holes into the bone, inserted screws into them, and snapped faux molars onto a plate fitted to the screws. I removed my hardware — full upper plate, lower implanted molars — every night for soaking. When I had a new girlfriend, I performed my dental procedures after she went to sleep, and made sure I waked early to restore my youth and virility.

One implant never took hold. Another soon wobbled and had to be removed. The remaining sites, opportunely opposite, held up for several months. I ate a small and tentative steak. Then the implant on the left loosened and left me. Even with only one screwed-in fraudulent molar, I was able to snap the plate in place and to chew for a year and a half. One day I did a poetry reading in Los Angeles. When I was going to bed in my hotel, I removed my upper plate, then pulled at the back lower partial. It wouldn't move. I put my thumbs at opposite sides and yanked. It wouldn't move. I tried again and failed. Finally, with an Arnold Schwarzenegger surge, I managed to pull it out—and my mouth filled with red saliva. I spat out two bloody mouthfuls, inspected the sink, and discovered that I had removed not only the prosthetic molar but the metal implant itself, disinterring a screw from my jawbone. Gums sagged themselves together to mend the gap, the wound stopped bleeding, I wrapped the hardware in a Kleenex, and flew back to New Hampshire to astonish my periodontist.

THERE'S ONE, THERE'S ONE

I'VE TOLD IT BEFORE, MY FAVORITE STORY ABOUT MY great-grandfather Ben Keneston on his sheep farm at the north end of Ragged Mountain. Moving his herd from one pasture to another, he decided to determine how many head there were. He set a hired man to count the creatures as they crossed the road but picked a fellow who never learned to cipher. Ben Keneston found him repeating, "There's one, there's one, there's one . . ."

Born in 1826 — 102 years before me — my great-grandfather clipped wool throughout the Civil War, and made a good penny selling it to New Hampshire's mills while they lacked cotton. In 1865 he decided to move from his Danbury mountain — it's a ski slope now — to Eagle Pond Farm in Wilmot. He bought this 1803 cape in a valley five miles south of the sheep farm and added rooms for his big family.

Ben's youngest child was born in 1878, my grandmother Kate, and I spent my childhood summers haying these fields with my grandfather, who died at seventy-seven. When Kate turned ninety-seven, Jane and I bought this place from her. I held Kate's hand as she died, and now I'm about to turn ninety. This farm has housed members of one family for almost 160 years. It's crowded with yesterday's detritus. I write these words beside a battered three-legged stool. I sat on this stool at ten or eleven, while I watched my grandfather milk six Holsteins in the barn's tie-up.

When Jane was alive and the five grandchildren were little, we speculated which of them might take over the farmhouse. After Jane died and the grandchildren aged toward college, I realized that nobody would. None would be freelance writers. Only retired rich folks live deep in the countryside. After I died my offspring would empty the house, toss the family's scattery abundance into a platoon of dumpsters, and sell the shell to somebody old who wanted to live beside Route 4 in Wilmot, New Hampshire.

I stayed alive and stayed alive and then came a family party late in my eighties, with my children and my granddaughter Allison. She is my daughter Philippa's first child, who grew up forty minutes away. When she was a baby, with Philippa's help she often called on Jane and me. I remember Jane falling asleep on the sofa with Allison lying full-length asleep on top of her. Some years later, Vassar admitted Allison early and she majored in art history with a minor in English, writing a thesis on Rembrandt's late drawings. When she graduated, it turned out that her salable talent was technological skill. She joined a business consultancy and worked at home, commanding electronic devices. Now she lives with her husband Will in New Hampshire, an hour and a half from my house. At my birthday party, she detached herself from the gang to tell me that when I died, she and Will would move into Eagle Pond Farm, where she could continue her work. In my generation, no one could have imagined a job like Allison's. She didn't ask me if she could live here; she told me she would.

And these were the happiest words I ever heard, a joy that depended on dying, therefore an inevitable, even a reliable, joy. The sheep farmer's great-great-granddaughter would continue the family residence. And after Allison and Will? There's one, there's one, there's one, and maybe there's another.

FROM APRIL THROUGH SEPTEMBER I WATCH BASE-
ball on television. In October it's the playoffs and the World
Series. I watched the Red Sox collapse as the worst team in
baseball in 2012, in 2013 win the World Series, and the next
two years become the worst team in baseball. In 2016 and 2017
things improved. When the Sox collapse mid-August, or don't,
football training camps have started. I like baseball because it's
slow. I like football because it's fast. I switch the channel from
baseball after a curveball and watch a screen pass to a wide re-
ceiver followed by an injury time-out, and when I click back to
baseball I see the same batter foul off the next pitch at ninety-
six miles an hour. I understand that in three hours of a New
England Patriots game, two and a half exhaust themselves in
penalties and standing around. Somehow the tension — in-
terceptions and concussions — makes it feel fast. It engorges
three hours in nine minutes of action.

And it exists on television. I remember before TV, when
radio football was hapless. My mother and I listened to Yale
games on the floor of our Connecticut living room, recording
each play with a pencil on a scorecard shaped like a football
field, available at your local gas station. (Back then there were
local gas stations.) (Back then a Yale player won the Heisman.)

(Back then Harvard went to the Rose Bowl.) My father got us tickets once a year for a Yale game. I made my parents laugh when, walking to the Bowl, I referred to Yale's schedule by calling it a sheh-*dooly*. When Yale beat Harvard to end a season, we crossed the field as we left, past a Harvard player sobbing fiercely. A grown-up crying?

Radio baseball was better than radio football. On Sunday drives my father turned on the Brooklyn Dodgers, WOR, play by play with Red Barber. When I was twelve, I sat in Yankee Stadium and watched the first game of the 1941 World Series, Dodgers and Yankees. Joe Gordon hit a home run to beat the Dodgers. My next and last attendance at a World Series was thirty-four years later, in 1975, after the Red Sox won the pennant. I had been writing about sports — for *Harper's Magazine, Sports Illustrated*, the *New York Times* — and became friends with a Chicago sportswriter who got tickets for Jane and me. From the center field bleachers in Fenway Park, we watched Luis Tiant's tonsils as he wound up and beat the Cincinnati Reds. In the sixth game Carlton Fisk hit a homer. In the seventh, he didn't.

ROMANCE

I REMEMBER WHEN I FIRST FELL FOR GIRLS. I THINK I lost my heart before I was supposed to have a groin-oriented heart. I must have been ten or eleven. My great-uncle Luther and his granddaughters came to the farm, and I lusted after the younger girl. I'll call her Rebecca. She must have been twelve or so, already beginning to swell twin bumps under her blouse. I followed her and her sister around, but I wanted to get Rebecca alone. In a comic book I read that someone—Archie?—got a girl's attention by claiming that he had seen a polka-dotted rabbit. Rebecca found it difficult to believe but followed me down the riverbank (where nobody could see us) to investigate. I leapt on her, straddling her waist, and kissed her neck. She was astonished, amused, called me "Donnie," and set me down. In the sixth grade I fell in love with Mary Beth Burgess, who sat beside me in art class. I drew badly and the teacher told me so, and I wept in front of Mary Beth. She liked it when I wept. In the summer my mother drove me to Mary Beth's house and we spent the afternoon playing catch. A year or two later I fell in love with an older woman named Barbara Darrow. She was fifteen and I wasn't. Again I expressed my love by leaping upon her and kissing her. It was a disaster, and I climbed down, saying, "I'm sorry. I left some snot on your ear."

EZRA POUND, MARIANNE MOORE, FRANKENSTEIN, AND T. S. ELIOT

THE *PARIS REVIEW* INVENTED THE LITERARY INTER-view, printed like a play without stage directions. George Plimpton did E. M. Forster in the first issue. In issue 2 an-other editor interviewed William Styron. I was poetry editor and did poet interviews: T. S. Eliot, Marianne Moore, and Ezra Pound. I've collected poet anecdotes in books that have gone out of print, which permits me to repeat myself. Eliot spoke like a member of Parliament, in finished, elegant sentences, humor gently disguised from idiots, in a diction that needed no tidying up. He dismissed "The Waste Land" as "rhythmical grumbling." Marianne Moore gave me lunch, reminding me that "Fritos are so nutritious." She revised the interview after I transcribed it. She had told me a story from her youth which ended, "I don't remember how old I was." Reading the tran-script, she transformed her diction: "Can you deduce my prob-able age?" Ezra Pound wanted to appear quick, witty, amusing with personal anecdotes, and proud of his inventions for mod-ernist poetry. He began a story or a rant, couldn't remember something, stopped, and fell back into miserable silence. On the tape I heard him say, over and over, "Turn that damned thing off."

It wasn't until recently that I remembered the first inter-view I ever did. I was a sophomore in Hamden High School, a flourishing suburb of New Haven, where the Shubert The-atre mounted plays on their way to Manhattan. Sometimes

a play came back from Broadway on tour. One day in 1943 the *New Haven Register* advertised a comedy coming to the Shubert. *Arsenic and Old Lace* had opened in New York in 1941 featuring Boris Karloff, and now Karloff would return in the touring company. The actor's name set my brain afire. I had grown up on horror movies, taking the bus from Hamden to downtown on Saturday afternoons to watch *Dracula, The Wolf Man,* and *Abbott and Costello Meet Frankenstein*. Karloff starred in the earliest *Frankenstein,* followed by *Bride of Frankenstein* and *Son of Frankenstein,* before he encountered Abbott and Costello.

Indirectly, my poetry comes out of Boris Karloff. When I was twelve, at home between horror movies, I read horror stories and poems by Edgar Allan Poe and turned to writing lines that engorged themselves on Poe's morbidity. When I went to Hamden High as a freshman, I no longer attended Saturday matinees. I knew I would be a poet the rest of my life, but when I read in the paper that Boris Karloff was coming to the city, I had to see *Arsenic and Old Lace*. I spent a month's allowance for an opening-night ticket. I loved every moment of the hit comedy of serial murder in which Karloff played a character called the Murderer, who didn't murder anybody onstage. Instead, two little old lady heroines served poisoned elderberry wine to depressed elderly gentlemen who had come by to inspect a spare room, then curled up and died after they sipped the ladies' hospitality. We were told that twelve old men were buried in the cellar. At the end of curtain calls for the large cast, twelve Equity corpses climbed up from their graves in the cellar and took a bow.

The audience left the theater in the good cheer of multiple homicide. I was thrilled, and my pleasure engendered a further plan. As an assistant editor on the Hamden High newspaper, the *Dial*, perhaps I could interview the horror master? Although we were merely a once-a-week school paper, the Shubert cultivated anything that hinted at public attention. Someone led me to a greenroom where I was introduced to the actor I had admired since fifth grade. His forehead looked like anybody's forehead, and Mr. Karloff was kindly, polite, and had nothing to say. The interview printed in the *Dial* was kindly, polite, and had nothing to say.

Of course I gloried in my acquaintance, my byline, and praise from my drama teacher Miss Miniter. Literary ambition continued to roar me home after school to write poems. More and more I became The Poet, maybe in my persona more than in my line breaks, diphthongs, and metaphors. I whispered mysterious sentences into the ears of fifteen-year-old girls. "Skeleton cowboys gallop in night's canyon." To embody my manner for myself, on Saturday nights I walked alone down the dark streets of New Haven, a mysterious figure wearing a black scarf, adolescent and terrifying, or terrified, as I crept through shadowy alleys. If only I looked like a monster! When I mounted the trolley home to my family's six-room house, I shut the door and returned to scribbling poems, which eventually got me interviews with poets as eldritch as T. S. Eliot, Marianne Moore, and Ezra Pound.

WAY WAY DOWN, WAY WAY UP

IN SEPTEMBER MY FAMILY THROWS ME A BIRTHDAY party at O's, a restaurant in Concord. Three years ago Linda drove me there, bringing a wheelchair in which my son Andrew pushed me from parking garage to table. As I had hoped, my daughter Philippa gave me plastic tubs of chili that I would freeze and defrost for dinner. Andrew gave me a year's worth of ten-year-old cheddar. I enjoyed my party and it wore me out. The next morning I felt wretched, as I did the next and the next, from late September all the way into February. All day every day I felt down, down, down—exhausted until circadian rhythms took over at suppertime. I felt almost human until 9 p.m. and bed. I slumped into sleep. I woke feeling weak, even moribund. Was I about to die? I was a mere eighty-six. When I woke up each morning I lagged through the *Concord Monitor* and the *Boston Globe*, then collapsed into dictating letters. My family has made a specialty of letters. My mother spent her eighties writing classmates from college, and after they died she wrote their daughters. When she herself died at ninety, I emptied her house and discovered that she had saved every letter I ever wrote her.

Now, when I had done four or five letters or emails, five or six more to go, fatigue began to hollow me out. I was not merely tired, much less sleepy. I felt a blackness drag from my toes through my trunk into the follicles of my hair. How could I keep on? I complained, and Andrew set up an appointment for me with Dr. Jordan, Andrew and Philippa both in atten-

dance. Much of the hour I closed my eyes, my head wagging from side to side as I heard them talk but couldn't pay attention.

A week or so later I admitted to myself that I had stopped writing my new book, notes and essays of memoir and meditation as I shuffled toward ninety. I couldn't add a sentence to the manuscript, which was hard, because I had written or tried to write every day since I was twelve. Usually at Thanksgiving Linda drove us to Andrew's house outside Boston, but this year the two-hour drive would be exhausting and the staircase impossible. My children and their families came to me instead. I kept on feeling down, even though my publisher brought out *The Selected Poems of Donald Hall*. Ten years earlier, my last selection had included every poem of mine I *liked* and it was seven times too long. I was US poet laureate back then, and I did one or two poetry readings a week, reading aloud for an hour and signing books for an hour. When the readings and signings stopped — old age and disability — the big old book went out of print, and it's depressing to be out of print, even as you shuffle toward ninety.

At Christmas it was sixty degrees, and my children dropped by and I saw my grandchildren. Maybe for the last time? Dull days repeated themselves. Mid-January I understood that I wouldn't have another birthday. Allison hadn't married yet. She would marry Will on October 1 and I wouldn't be there. With Linda I watched movies I couldn't follow; Linda paused the Netflix to explain. Daytimes I lived in two chairs. My housekeeper Carole had found me an up-and-down mechanical chair for the parlor, where I dictated letters and watched

MSNBC, where I drank a whey-banana milkshake for lunch and picked at a dinnertime Lean Cuisine. Otherwise I sat in the living room, in an overstuffed blue chair Carole revised for my health. She has vacuumed my carpet and washed my shirts three mornings a week for twenty-five years, and over the decades has evolved from housekeeping to eldercare. A few years ago she shuddered as she watched me plop onto this puffy chair with my head just missing the bookcase beside it. She assembled and installed a platform that lifted the seat a foot so that I could plop down without a concussion.

One morning two weeks after Christmas, I couldn't pee. It was early, and no one answered at the New London Medical Center. I telephoned Dr. Jordan at home. "Dial 911," he said. The New London ambulance arrived, strapped me to a stretcher, and hauled me to Emergency, twenty minutes away. Soon my urine dribbled into a catheter. Then a nurse took me to an x-ray machine and wouldn't say why. Was urinary retention a symptom of heart cancer? X-rays attended to my corpse-to-be. Back in my room a doctor disclosed my monumental constipation. My inability to piss was caused by a bloated intestine pushing against my bladder. Dimly I remembered that I had recently neglected to defecate. A nurse ripped out the bloody catheter and I was subjected to suppositories, enemas, and laxatives.

With me I had brought weekly issues of *The Economist* and *The New Yorker*. I could read a page of *The Economist*, skipping only a paragraph or two, but *The New Yorker* was too difficult. A television set loomed opposite my bed, and its remote included many channel numbers that could not be summoned.

The set would not deliver MSNBC. I got my news by processing Fox News backward. One Sunday I found the NFL playoffs and watched the New England Patriots lose to the Denver Broncos. Fox News played better football.

When my personal sewage system calmed down, I was ready to leave the hospital. I felt as horrid as I had felt since my birthday, but longed for silence and solitude. A young nurse named James arranged for my discharge on a Tuesday. Linda picked me up in the afternoon to drive me home. She spent the night and at 7 a.m. left for work. I crawled through the day with my mouth hanging open between bed and bed. Beside my blue living room chair sat the box that entombed my abandoned book. I considered looking at a page, but it would be miserable to glance at what I could no longer give myself to. My children telephoned and I told them I was dying. I telephoned Linda after she finished her workday to remind her that I was dying. When a stranger wanted to come calling, I told him I was almost dead.

Three days later I felt warm and the thermometer read 100 degrees. Kendel stopped by and heard me panting with short quick breaths. I telephoned Dr. Jordan's office. His nurse Koreen told me to dial 911. Kendel called 911 and they told her my name and address. I called Linda without answer. The ambulance came and attendants strapped me to the same old gurney. I persuaded Kendel not to come to the hospital but to lock up the house, set the security system's alarm, and telephone everybody. In Emergency my clothes were peeled away to expose my body to inspection. Again I was an object subject to brutalities and banalities of attention. My wristwatch van-

ished together with the button that summoned volunteer fire-men. I lay in a room bare except for metallic devices. Men and women examined what they always examine and reexamine. Somebody attached small round discs all over my torso, ex-truding wires that led to a box. Somebody spoke of UTI, which appears to mean urinary tract infection. I remembered a cath-eter. A nurse arranged a pole beside me with a bag of liquid dripping through a needle into my arm. Everyone vanished. For the moment I didn't love solitude. Maybe in April someone would find a desiccated corpse.

When I thought I heard footsteps in the corridor outside my closed door, I shouted, or I tried to shout. The door opened. It was Linda! I reached up to see if she was real and detached a wire from my chest, which bled a little. Kendel had tele-phoned her, and now she crawled into bed with me and my equipment. I told her I had been abandoned. She left the door open and I caught sight of a male figure in the corridor. When I yelled, he turned and Linda leapt out of bed. The man as-sured me that soon my room would be ready, and unhooked something massive and aluminum from the wall beside me. He disentangled it, rolled it toward the bed, removed a metal-lic cover, and it became a TV. He handed me a control listing networks and numbers for cable. I pressed a number for news, although I would be dead for the election.

When I left the same hospital a week before, I watched my room be cleansed of me. Everything I had touched was dis-carded or sent home — miscellaneous water cups, a pink re-ceptacle for dentures, my dental plates, the tube of glue that stuck dentures to gums, a box of Kleenex, two plastic piss bot-

tles, the clothes I arrived in, my wristwatch, my push button, and my glasses. Items I could not carry with me, like the bed and the floor, underwent industrial cleansing. And now I was suddenly pushed into a newly sanitized room for the rest of my life. I calmed down and Linda left me, drove back, and slept at the house where I used to live. A nurse leaned over to repair my chest wire.

The next morning of confusion I was assaulted by a man, probably a nurse, armed with electric clippers. I should say that for a dozen years I had worn a full beard that curled itself monumentally around my face's moonscape of wrinkles. Until a decade ago, I trimmed and brushed my hair and my beard, but in the spring of 2007 Dr. Jordan had me rub testosterone on my chest every morning. Head hair and beard hair erupted, enlarging me into a monster of mythic grandiosity, a blotched blob of pale skin in a shaggy gray-brown aboriginal forest. When I did poetry reading after poetry reading as poet laureate, my beard was rewarded with standing ovations. Twice Ireland invited me and my hair to read, in Galway and Limerick. When a back-home photographer accomplished a masterly close-up of my beard and me, my editor at Houghton Mifflin Harcourt asked me to write a book so that she could use my photograph for the cover. So I wrote *Essays After Eighty*. And now on the morning of the first day of my latest dying, someone was clipping off my beard. Did he think that a demented ninety-year-old hominid had wandered into New London Hospital? I bit his hand.

The days, the days. The doctors wore on, the nurses wore on. On Sunday I watched the worst Super Bowl in history. I tried

to nap. I tried to read, but after scanning one *Economist* paragraph I couldn't handle another. I would never read again, as I would never write again. At night I stared at nothing while the night nurse, poring over the computer, figured out my nighttime meds, which were never the same two days in a row. How long would it take to die? No one told me what was happening. No one was in charge of my body. I slept, I woke for tests or medication, I lay abed, awake and senseless, my grotesque mouth hanging open. Every day Kendel brought mail, which accumulated unattended on a bench. Carole came to visit, Philippa and Jerry, Andrew and Natalie, Allison and Will. I summoned energy and it wouldn't answer. Dr. Jordan dropped by and told me that I had congestive heart disease. He didn't speak of treatment. My mother died of it at ninety, a month short of ninety-one. In her Connecticut house she had lived through congestive episodes for ten years, gasping alone until she dialed 911. Each time the ambulance deposited her for a week at the New Haven Hospital. Jane and I drove from New Hampshire to welcome her back to her house and stay with her until she strengthened. Now when I returned to my house, who would take care of me until I didn't strengthen?

For months I had worked with a lawyer on a new last will and testament, to include my grown-up grandchildren along with my children. My friend Jeff White had found me the lawyer. We corresponded, we talked on the phone, he visited and we talked. Now I feared I would die before I signed it, and Kendel arranged for the lawyer to drive to the hospital with the document and two of his staff as witnesses. On February 10

I alerted nurses and staff to the event, and inside my hospital room put my initials on fifty pages, my signature on three.

Each day someone — a nurse, a physical therapist — helped me learn to walk again. Walking deserts you in extreme old age. Twenty-four hours after an ambulance, you cannot move your feet. Along with learning to walk again, insofar as it's walking when you push a rollator, I touched briefly on my old professional life when my literary agent dropped by. Soon she would become my literary executor. Wendy Strothman and I spoke of a Donald Hall memorial in New York City. For half an hour I listed and unlisted speakers. Most were dead.

The next day was Friday, and I could walk, pushing my equipment. My UTI had concluded, so they removed my antibiotic drip. My breathing was normal and so was my BP and my blood sugar. A nurse brought up the subject of discharge. I had not allowed myself to consider discharge. Sure, I wanted to get out of the hospital, but Linda had flown off to see a friend in Florida. Would visiting nurses come to my house? What was the hospital doing? What was I doing? I telephoned Philippa to pick me up and drive me home. The hospital struggled through discharge, retrieved my old medicine bottles, and provided new ones. I dressed for the unhospital world, putting on the clothes dragged off in Emergency. A nurse pushed me in a wheelchair to the hospital exit, Philippa following with my rollator, the medical staff waving goodbye. Prominent among the crowd I saw the man who tried to shave my beard. He wore a Band-Aid on his hand.

It was extraordinary and terrifying to push my rollator

into my house and sit upright in my blue living room chair. Philippa drove to Hannaford's to shop for food. When she returned, she started to tuck things away in my refrigerator and discovered that the refrigerator had died instead of me. Everything in the freezer had thawed. What remained of Philippa's birthday chili, as well as my soggy anthology of Lean Cuisine and Stouffer's, was fit not for supper but for the dump. Philippa did the dumping and went home to telephone Sears. How did I get through the night? I got through the night. Kendel brought me a breakfast sandwich. A new refrigerator arrived, followed by Philippa with new chili. Medical assistance appeared from New London as a visiting nurse. "Have you any pain?" I never had any pain. The nurse measured my BP and vanished. I napped. I looked at the pile of letters. I rollated between two chairs, estranged from the world of what had happened.

The next day, a physical therapist named Angela came to examine me and work me out. In the bedroom she had me raise my legs to the ceiling, then stood me at the kitchen sink, my hands grabbing the stainless steel edge, to kick forward twelve times, backward twelve times, twelve times left and twelve times right. She walked me, pushing my rollator up and down the length of the ground floor, bedroom through living room through kitchen, back from kitchen through living room and hall to bedroom. "You have to *walk*." She worked me out three days a week.

In the kitchen one day Angela pointed to a further closed door that led into the unheated toolshed and onward toward my grandparents' 1865 woodshed and outhouse. "Where's

that go?" We entered the old toolroom, cluttered with last autumn's leaves, with its abandoned icebox, woodbox, saws, sickles, drills, shovels, and scythes. According to the season, skunks, garter snakes, squirrels, chipmunks, and rats skittered through. Beyond was the woodshed door, and as we approached I remembered: there was a garage where the woodshed used to be! From the toolshed floor to the garage surface slanted a cement ramp with wooden rails close on each side, so that years ago in winter I could walk to the Honda without undergoing ice or snow. Yes, yes, I had backed my car into the garage door! Again and again. After I totaled the car I forgot I had a garage.

Looking at the ramp, for the first time in two months I felt somewhat aware of the world outside me. I began to feel like moving instead of sitting still. Maybe I was going to die, but not right now. When Linda returned from Florida, maybe she could back into the garage. Could I squirm down the stepless ramp to the passenger door of her car? Could she drive me to dinner at the Millstone? From parking lot to booth, the entrance was flat enough for my rollator. Could I eat five stuffed mushrooms? Four? After Angela left, when I lay down now, I was actually sleepy. I had known for months that I would miss Allison's wedding on October 1. If I stayed alive, even barely alive, what would I wear? I asked Kendel, who told me about T-shirts online that were printed with bow ties and red roses. At my next September birthday, if I had one, Philippa could give me black sweats without elastic cuffs. I was astonished as slowly my death began to recede. I could do everything but write. Two days later, Dr. Jordan paid a house call and we spoke about the Red Sox and palliative care. By now I had no trouble

breathing. By now Pam, my trainer, could work me out again, twice a week.

Carole and Steve Colburn go on holiday twice a year, and in March I felt well enough to undergo their absence. They flew to Florida's panhandle. The visiting nurse came once a week, and my BP was acceptable. Angela reached the end of Medicare's permitted physical therapy. When Carole came back I was writing twelve letters a day, telling everyone that I wasn't about to die, not yet, but that I couldn't write my book anymore. Carole began housekeeping here when Jane was alive and well, twenty-five years ago, because I wanted Jane to make poems, not to do the laundry. When Jane took sick and died, I needed help all the more. When Carole this time returned from Florida, she remembered that in the past I had complained about not writing and had learned ways to trick myself back to work. She had known me to move to a different chair for writing, or into a different room, or to switch white paper pads for yellow ones, or to try out a pen with purple ink. I found a pink pad and a green pen. I sat at the dining room table and glanced over a list of topics from six months ago. I sat for an hour and didn't write a word. The next day I wrote five yellow legal-sized pages. Five days and one essay later, when Ira Glass invited me to Portsmouth, New Hampshire, an hour and a half away, it did not depress me.

IN 1998 Ira Glass had interviewed me for an hour on his public radio show, *This American Life*. It was not three years after Jane's death, and her dying was my only thought all day every day. On that program we spoke of nothing except Jane's death.

He was the best interviewer of my public radio life, better even than the great Terry Gross, Diane Rehm, or Garrison Keillor. Glass was utterly attentive, alert, intelligent, responsive, and eloquent. When I left his Chicago studio in 1998 I felt shriven, I felt clear, I felt elevated. Word of our program spread, and Glass sold tapes and CDs, sending me royalties. Then a few years ago he wrote me about a stage adaptation of *This American Life* with dancers and Glass himself. He needed permission to include my poem about Jane's "Last Days." A radio program on the stage? Dancers? The mind boggled. The boggled mind and its Boston publisher gave permission. I received further royalty checks from *Three Acts, Two Dancers, One Radio Host*. Now a Lincoln Town Car dispatched by Ira Glass would drive Linda and me across the state to a performance in Portsmouth. Glass had thought of my family and provided tickets for my son and my daughter with their spouses, and for Allison with Will. When our driver deposited us at the Music Hall's door, Linda led me to an accessible pisshole, always an issue for the disabled. On the last day of April we sat in the front row to watch the show.

You should have been there. A girl in a tutu, who turned out to be Anna Bass, held up a piece of cardboard labeled ACT ONE. Two dancers, Anna Bass and Monica Bill Barnes, danced their way onstage. Dressed alike, they moved unpredictably and in unison. They were charming and pretty and funny, and their choreography was narrative and intelligent. So was Ira Glass. So were the objects that cluttered and uncluttered the stage, concealing and revealing dancers, or sprouting an immense arch of balloons linked together, three hundred or so.

Everything was snappy, especially Ira, dancing with Anna and Monica. He is not a dancer and he danced. Mostly he talked, sounding as if he improvised. The dancers' simultaneous steps accorded with Glass's talk—yet *what* did Glass say? Everyone listening laughed profoundly but no one remembered anything two minutes after, when everyone collapsed again into another Atlantic of laughter. What was *Three Acts* about? Good question. Maybe it was about what it was like to live on earth. At the beginning we entered the lives of Monica and Anna. Later we heard the brief radio voice of a man who undertook selling himself to his wife. We heard wit, we heard intelligence, we heard surprise, we heard sentences and saw bodies leap to combine thought and beauty with comic extravagance. We saw Anna and Monica dancing while each held aloft with no hands a full-sized wooden chair, a dowel gripped between teeth. Impossible! Afterward they revealed to Linda that the wood was balsa.

Where could my interview fit in? My memory of an hour in 1998 did not include anything amusing, anything light—only devastation as Ira Glass extracted my distress and grief without limit. In *Three Acts, Two Dancers, One Radio Host* how could our dialogue display itself? On the stage Glass pivoted toward me, knowing where I would sit, and introduced me to the crowd. It was a moment for me to stand, but I can't stand except by hanging on to my rollator. Glass pretended to push a button, and I heard my voice, recorded eighteen years earlier, speaking a poem about Jane's final moments and final words. I spoke of helping Jane to sit on a commode, wiping her bottom when Jane could no longer move—and when I looked

away from Jane for a moment, she had somehow crossed the room. Monica Bill Barnes and Anna Bass, dance costumes concealed under plain cloth, mimed the impossible movement. Jane's voice — my 1998 voice quoting Jane — lamented, "No more fucking. No more fucking!"

In the Portsmouth Music Hall, for six or seven minutes, the uproaring audience slid into immaculate silence. No one coughed, no one sneezed, no one appeared to breathe. After levity's brightness a porous and textured darkness covered every seat in the theater. Silence extended into silence, and Ira Glass gestured toward me again. I wiped new tears away. Listening to every fragment of my old speech, I had inhabited the original moment. In a theater by the Atlantic, among an audience of a thousand, at the age of eighty-six I entered the grief of my mid-sixties in another century.

Now I understood how death and desolation fit into the riotous joy and laughter at the Music Hall in Portsmouth. The emotional intricacy and urgency of human life expresses itself most fiercely in contradiction. If any feeling makes a sunny interminable sky, the feeling is a lie and the sky is a lie. If at a moment of sun a part of the landscape collapses in earthquake, then feeling may establish itself. In any apparatus of art, there is no north that is not also south — not in *Gilgamesh*, not in *Doonesbury*, not in Henry King's "The Exequy." Paradiso validates Inferno. Yes no. No yes. Several times in my life when I have concluded a poem, satisfied with its language, I feared that it failed because it thrust in one direction only. Several times I have later discovered that the love was so overwhelming and so monumentally carnal that in my poem love suf-

fered death. Mortality interrupted ecstasy to embody emotion. W. B. Yeats has the Bishop tell Crazy Jane to live in a heavenly mansion, and Crazy Jane responds, "But Love has pitched his mansion in / The place of excrement." Catullus told Lesbia, *"Odi et amo."* Only the wrenching apart permits or reveals the wholeness. Enantiodromia. Up and down. Down and up. Way way down, way way up. A carnival of losses.

At the curtain there was no curtain. Ira Glass waved the printed word CURTAIN amid a thunderstorm of confetti and the principals bowed. The audience stood, except for one who couldn't stand, and applauded with a gusto that endured and endured. The audience seemed as astonished and overwhelmed as I was. I had been told that I could go backstage at the end, but almost immediately backstage came to me. Linda rose from the seat beside me and Glass sat down. My children approached. Beside me suddenly were Monica and Anna, happy dancers and — everybody talking — stage managers and grips and lighting engineers and choreographers and goodness knows who else, an ecstatic conglomerate. I talked, I talked, I talked. Certainly I had not talked for a year so much or so energetically. Before the show my family had gathered for dinner together, and now I talked with Andrew, with Philippa, with Allison. I told or tried to tell Ira Glass how astonishing I found his dancers, his radio host, his or everybody's theatrical invention, sight and sound, motion and emotion. I tried to tell him what he had done, the north-south of riotous joyous laughter followed by vast grieving silence, the two making one.

My strong son helped me outside and into the car. The meticulous driver drove us an hour and a half home. I had stayed

awake and vibrant after midnight for the first time in so many years. I knew that I would turn eighty-eight in September, and that on October 1 I would attend Allison's wedding.

THAT WAS late April. Early in May the composer Herschel Garfein produced a concert of my poems, sung by a tenor with a pianist. My children could come, and Kendel and Pam — the concert hall only a few miles from my house — together with a hundred friends and strangers. Before we heard the poems sung, I read them aloud. A tenor and a pianist made their art. Afterward I answered questions. For decades I had traveled coast to coast and abroad to read my poems and later to answer questions, to talk and joke with my listeners. I loved doing it again, even if only for twenty minutes. In the morning Philippa telephoned in joy: *"You were funny!"*

TREE DAY

MY BIG TREE FELL DOWN, THE 150-YEAR-OLD ROCK maple in my front yard. When I came here at age nine or ten, in the 1930s, my grandfather hung ropes from it to make me a swing, and I pumped hard to lie flat out on the air. Forty years later, when Jane and I moved here to stay, maple branches hovered hugely over the porch, shading the house all summer. The big tree aged as I did, and one great wing of it died five years ago. I hired it sawed off and carted away, and each spring watched to see if the remaining branches put out new leaves. Even this April they budded a frail green. Ten feet off the ground a patch of the trunk had gone rotten, and in the rot raspberries grew. In the summer's drought I looked for a bear with a sweet tooth to drop by midday.

My driveway is U-shaped, and the big old tree grew in the middle. I hoped the maple might outlive me. I feared that it might fall onto my old house where disabilities creep me from room to room. It was late in July that a monumental wind took the tree down, its great length lapsing away from the house into a hayfield. I did not hear it fall. What would be the noise of green leaves and old branches falling on summer grass? In the late light of afternoon I saw its long body snapped off at the raspberries ten feet above the ground, its green fragile wreckage stretched out wriggling in the wind that persisted.

It was a bad day for trees in the neighborhood. Timber workers offered their services, and rang my assistant Kendel's doorbell or left a note at my door. Three men who live two

miles away offered to do the job, in the hours after their regular workdays ended. Rick Maines helped tend our fields when Jane was alive, and he would get help from his brothers-in-law Brian and Gordon Ordway. (Rick had married the Ordways' sister, Linda — who died young years ago, at thirty-seven, a decade younger than Jane.) The Ordways and I are connected way back. When I was a child here in the summers, I sat in my family pew at church in front of the Ordway family, including a boy my age who became Brian and Gordon's father. Every Sunday morning, late 1930s into the '40s, their boy-father sat behind me among his brothers and sisters. He died a few years ago. I remember his brother Perley, who remains alive at ninety-three.

Now the three men worked from 4 p.m. into darkness, sawing and cutting branches and stacking them for the dump. I watched them knock the stump down, its ten stout feet, sawing it almost through at the bottom, then pushing it over with a big-wheeled tractor. When it was too dark to work they left a pile of wood behind, and picked it up the next afternoon before they raked my lawn and driveway clean. They charged little. There are some businesses in my town, including the best car repair shop, that charge as much as the United States does. The Ordways came up with a New Hampshire figure.

ONE MORE story derives from the demise of my tree. The tree blew down in July, and of course nobody knows when my granddaughter Allison and her husband Will will move into this old house, extending one family's residence since 1865. They will take over here when I die, but now I was able, with

the help of a windstorm, to give them a wedding present that should last awhile. When I was a boy, elms lined Route 4, but by the time Jane and I arrived, Dutch elm disease had killed them all. A few years ago, Philippa told me of newly bred elms that were immune. She and I conspired, and acting as my agent, she bought a new American elm, and after the great stump was removed a slim four-foot elm sapling took the maple's place. Philippa and Jerry, my son-in-law, planted it on a Sunday early in September while Allison and Will and I looked on. It was Tree Day, which I proclaim a family holiday. For now the elm will require watering, three doses of three gallons a week, applied by my helpers. The sapling came with a bronze plaque inscribed to the future tenants, to be affixed to the elm's eventual trunk. I am free to imagine another grand-child swinging from another branch of another tree.

ACKNOWLEDGMENTS

"Necropoetics" (as "The Poetry of Death") and "Solitude Double Solitude" (as "Between Solitude and Loneliness") appeared in *The New Yorker* online. The latter was also in *Rigas Laiks* (Latvia); it also published "Losing My Teeth," which also appeared in *80 Things to Do When You Turn 80*. The three lines in "The Last Poem" were published in the *Concord Monitor* and the *Boston Globe*. "The Wild Heifers" introduced a reprint of *String Too Short to Be Saved*. "Richard Wilbur" appeared in *Poetry*, and "Prosaic Laureates" in the *American Poetry Review*. *Mudfish* printed "Fucking" and "Mudfish Pissing." Anecdotes from "Theodore Roethke" turn up in the introduction to a paperback reprint of *The Glass House*, a biography by Allan Seager (University of Michigan Press).

"Like Musical Instruments . . ." is reprinted by permission from *Light and Shade* (Coffee House Press, 2006). Copyright © 2006 by Tom Clark. "My Son My Executioner," "Ox-Cart Man," and "Weeds and Peonies" from *White Apples and the Taste of Stone: Selected Poems, 1946–2006* by Donald Hall. Copyright © 2006 by Donald Hall. Reprinted by permission of Houghton Mifflin Harcourt Publishing Company. All rights reserved. "Pissing Beside Donald Hall" from *Mudfish* #17, © 2012 Box Turtle Press, New York, NY. Jane Kenyon, "Twilight: After Haying" and excerpts from "Pharaoh" and "Otherwise" from *Collected Poems*. Copyright © 2005 by The Estate of Jane Kenyon. Reprinted with the permission of The Permissions Company, Inc., on behalf of Graywolf Press, Minneapolis, Minnesota, www.graywolfpress.org. Excerpt from "Tywater" from *The Beautiful Changes and Other Poems* by Richard Wilbur. Copyright 1947, renewed © 1972 by Richard Wilbur. Reprinted by permission of Houghton Mifflin Harcourt Publishing Company. All rights reserved.

Photograph on page 42: Stephen Blos 1974. Illustration on page 192 reproduced courtesy of http://hddfm.com/clip-art/baseball-clipart-free.html.